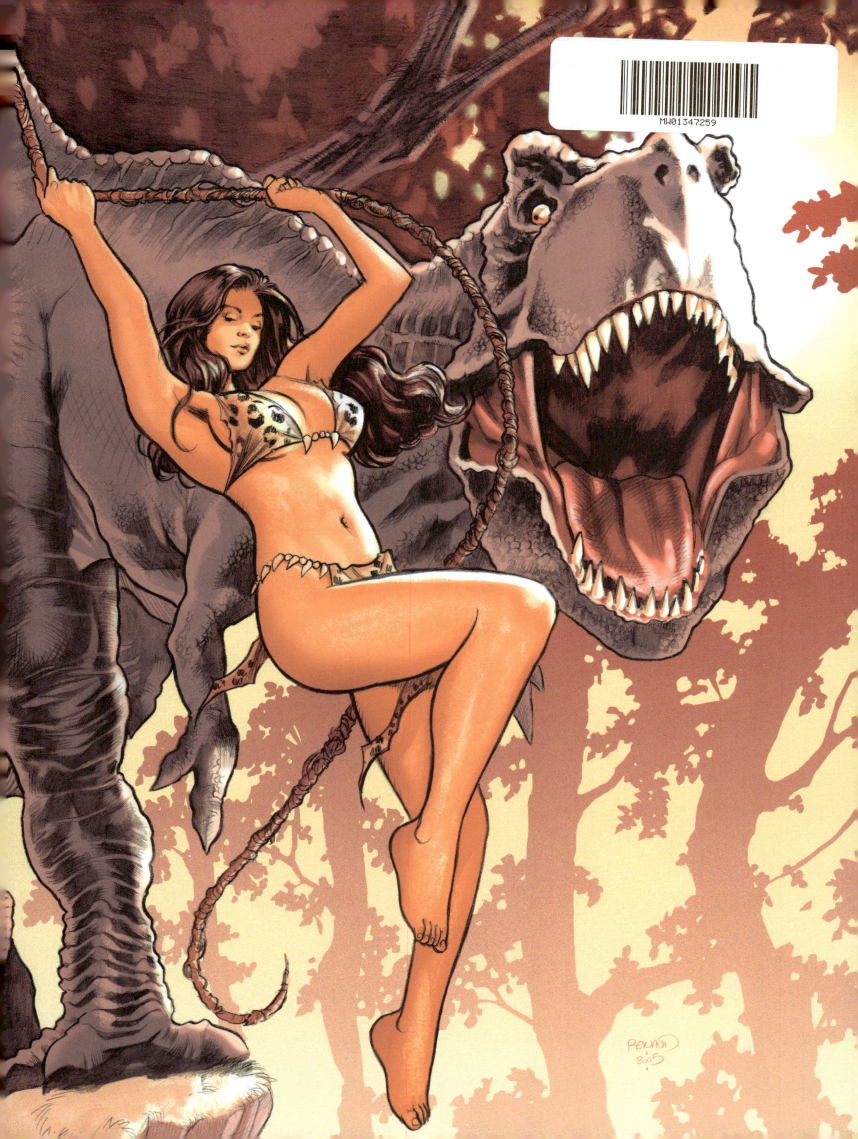

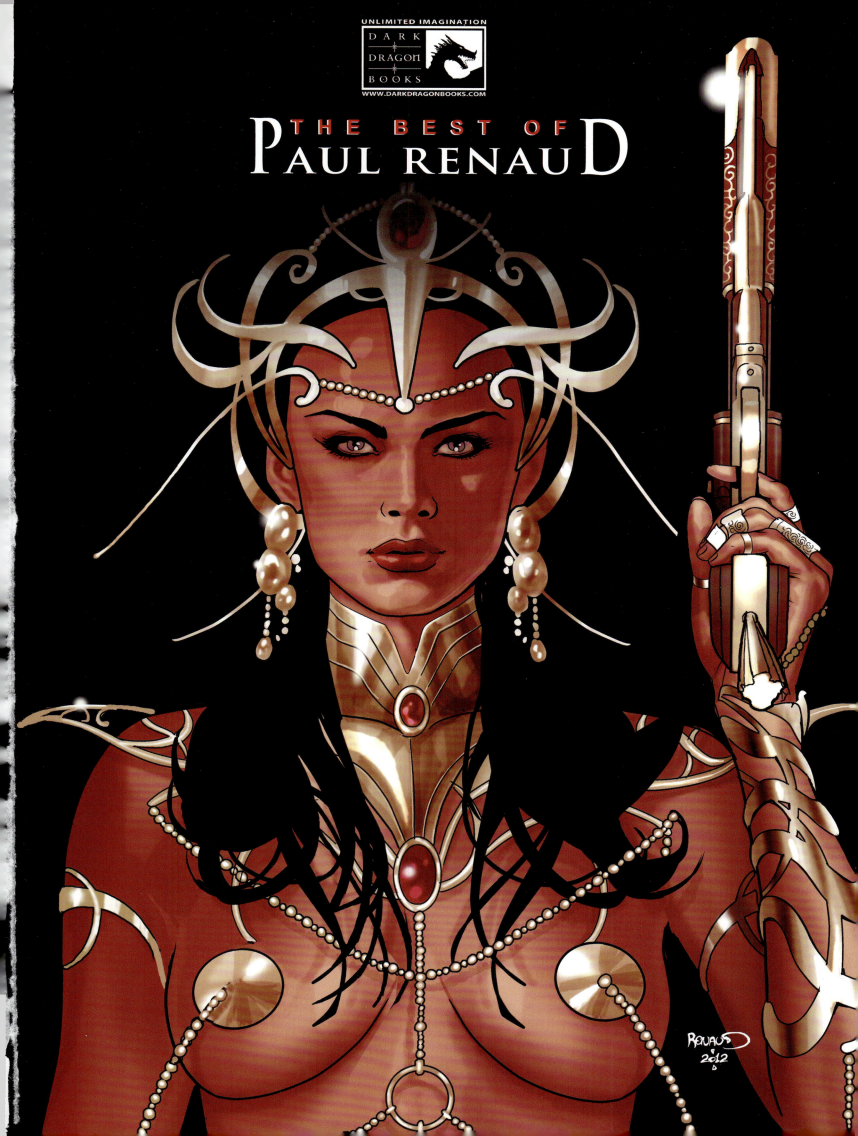

ARTIST: PAUL RENAUD
PUBLISHER: AMIN GEMEI

ISBN: 978-94-6078-214-5

ARTISTS- BLOGS & WEBSITE
PAUL RENAUD: WWW.PAULRENAUD.COM
WWW.FACEBOOK.COM/PAUL.RENAUD

WWW.DARKDRAGONBOOKS.COM
WWW.FACEBOOK.COM/DARKDRAGONBOOKS

Copyright © Dark Dragon Books, Breda. All rights reserved. All artwork is © 2014 Paul Renaud and may not be reprinted without the express permission of the artist.

All rights reserved. All characters are ™ and © their individual owners and are included herein solely for the purpose of scholarly review.

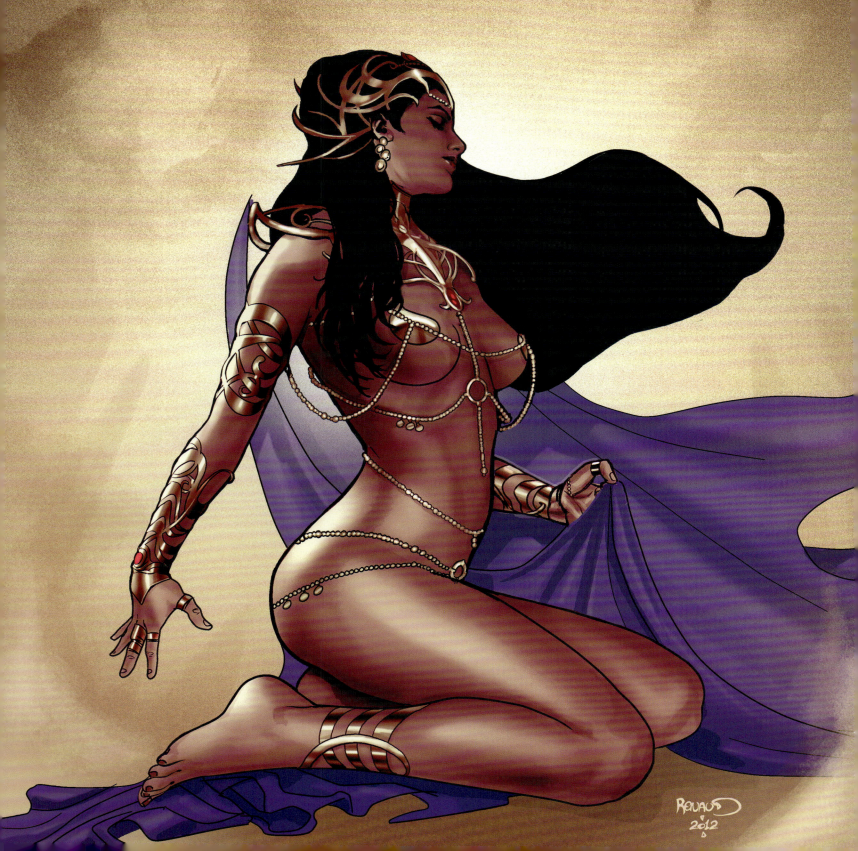

About Paul Renaud

Paul Renaud is a French comic book artist who became famous for his cover artwork for many U.S. publishers such as Dynamite, Dark Horse, Image and Marvel. He also did interior artwork on Cavewoman, Red Sonja, Fear Agent and Avengers. In Europe, he has mainly been published by those who noticed his impact on U.S. publishers, although he also had a couple of illustrations published such as the art book 'Red Sonja in Beeld' for Dark Dragon Books.

When asked, "Who are your artistic influences?" Paul Renaud says, "I've got quite a lot of heroes". At around age 12, Paul got introduced to the Marvel Comics for the first time. So he was influenced by artists such as John Byrne, Frank Miller, Neal Adams, Don Newton, and Art Adams. But two artists stood out in particular: Paul Smith, and Michael Golden. Later came Frank Frazetta as well as Alan Davis, Steve Rude, Kevin Nowlan, Rick Leonardi, and Mike Mignola – and he still follows everything they do. As a teenager he discovered Moebius, and fell deeply in love with his work. It made him realize that he wanted to do comic art as a living. Although Paul's covers made him famous in large parts of the comic industry, he's working hard on a career as an interior artist as well. "Storytelling in comics is what I like best".

Paul Renaud lives in Toulouse, France, with Marion and their cat, Mooki.

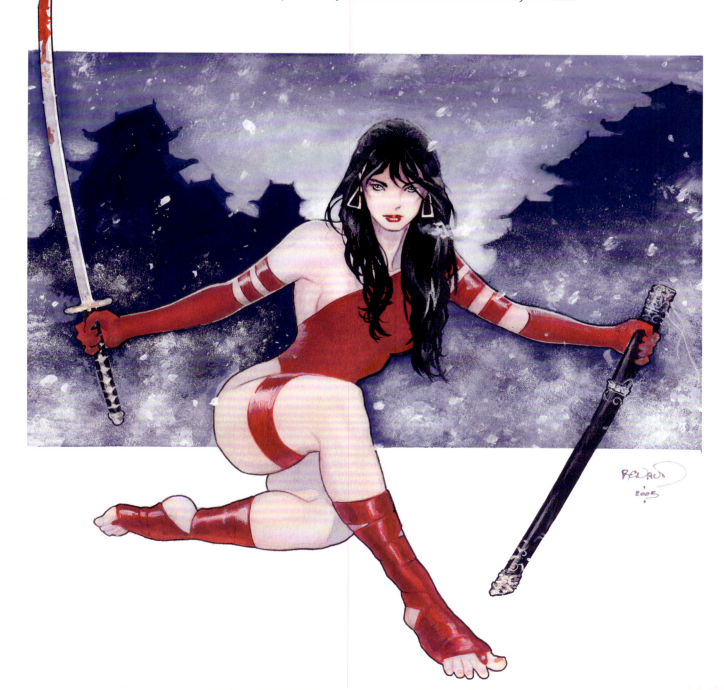

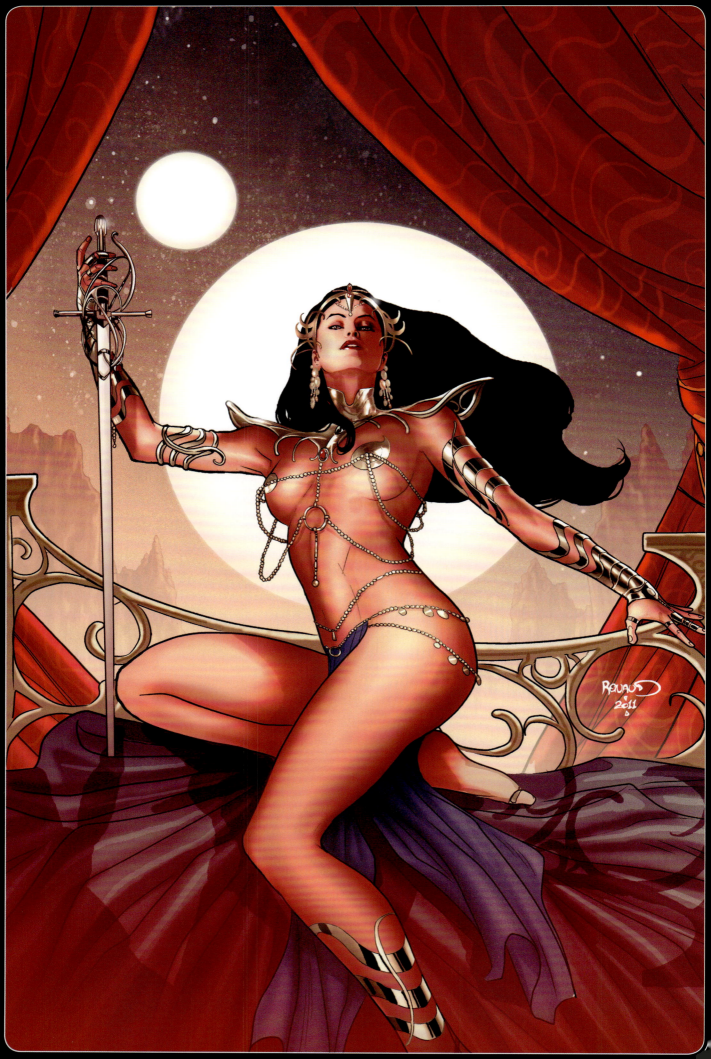

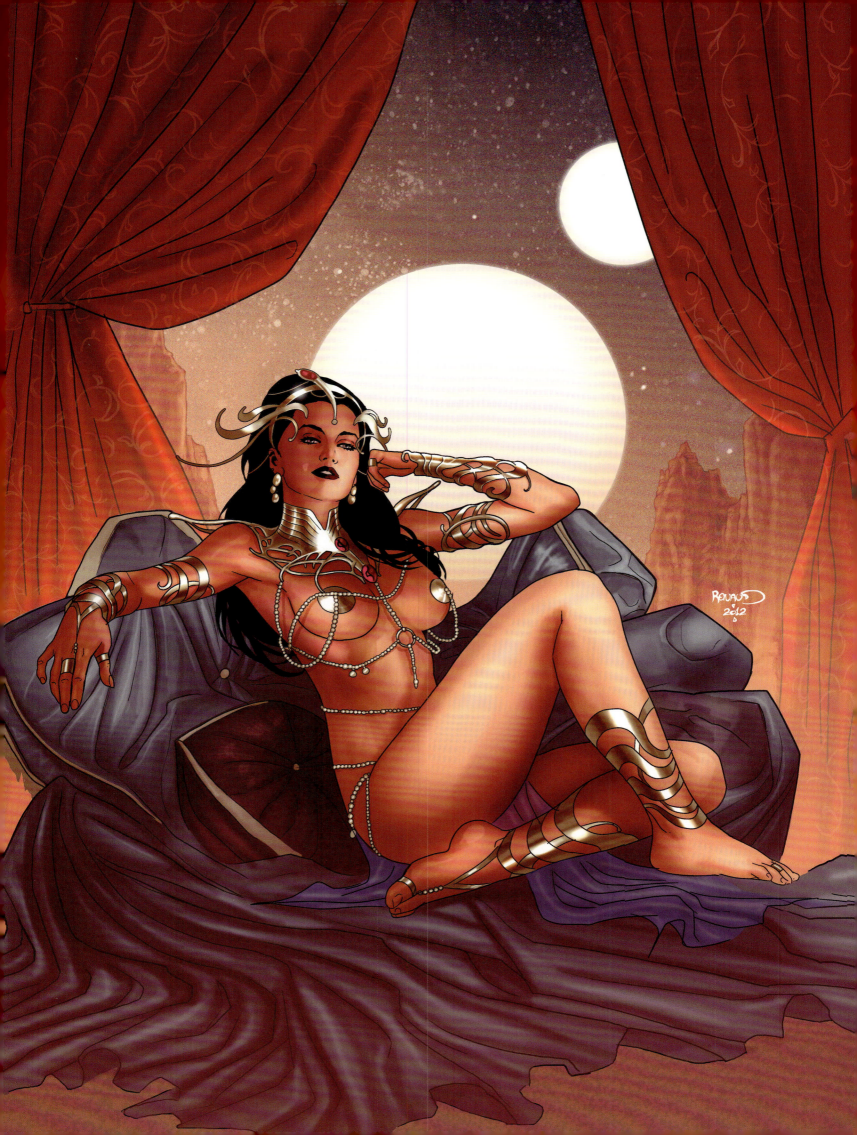

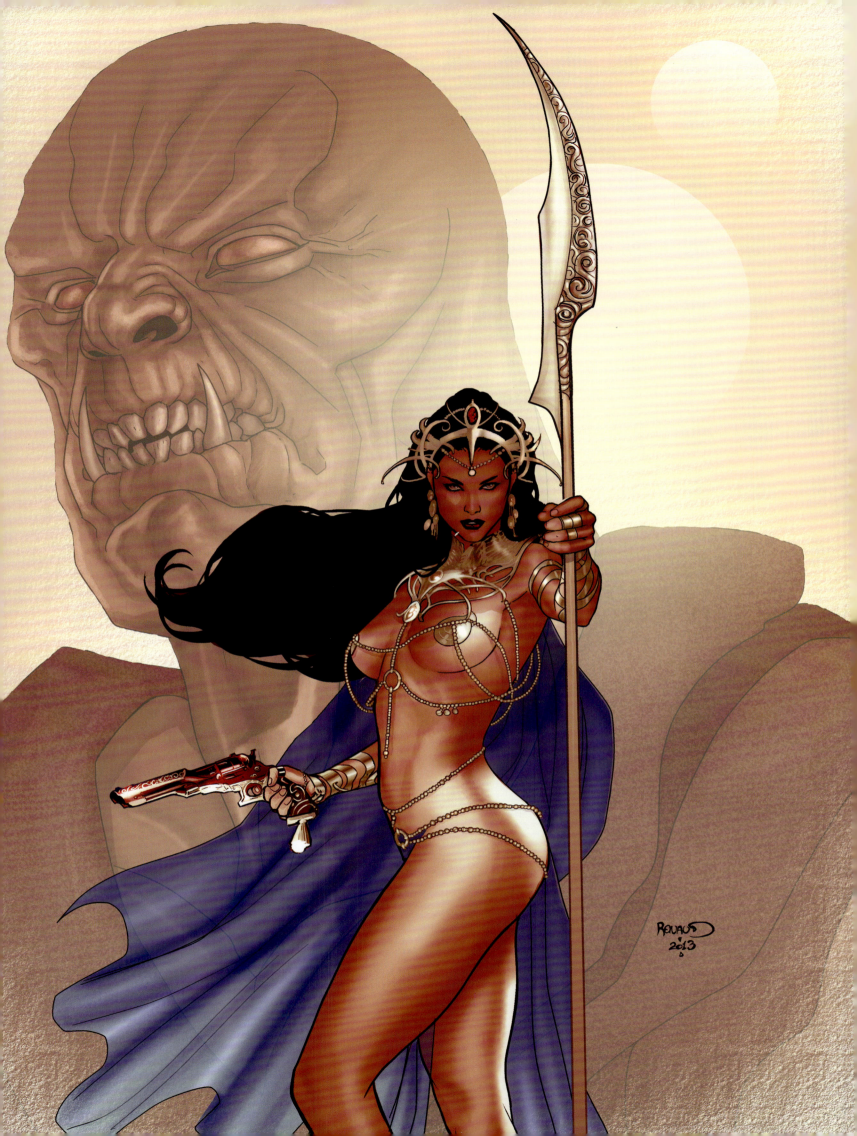

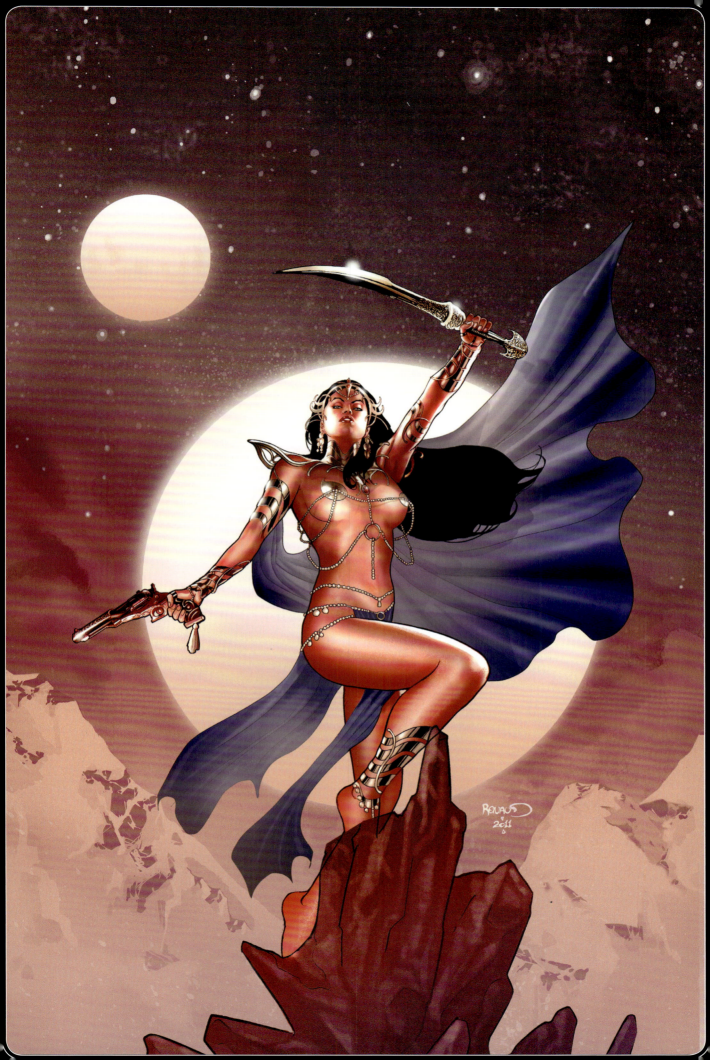

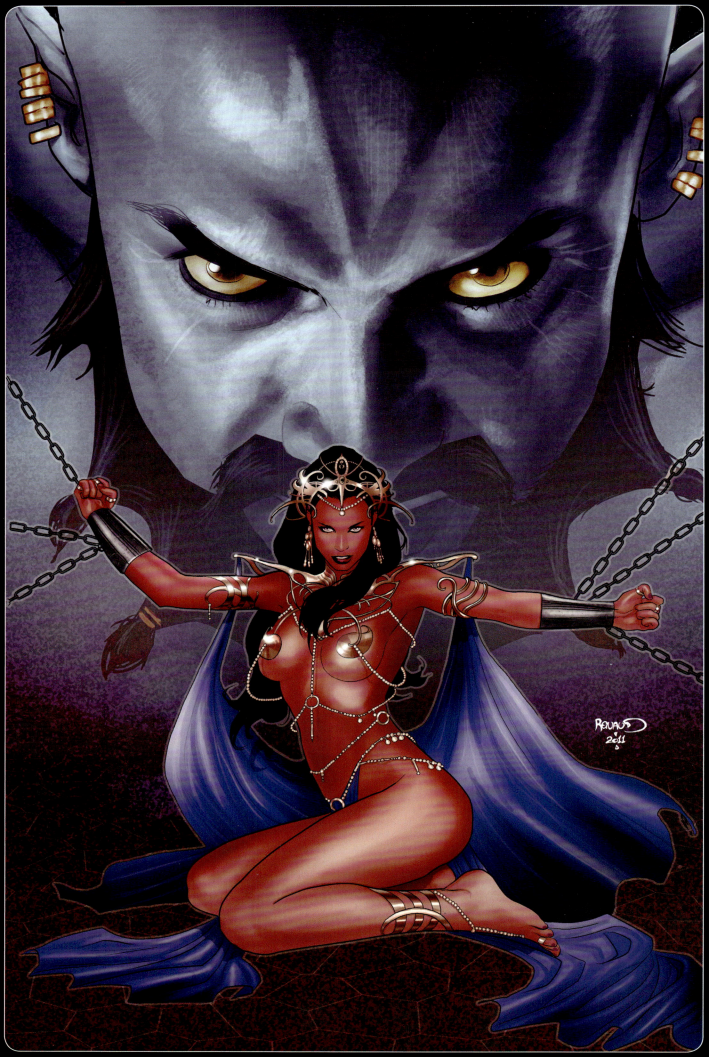

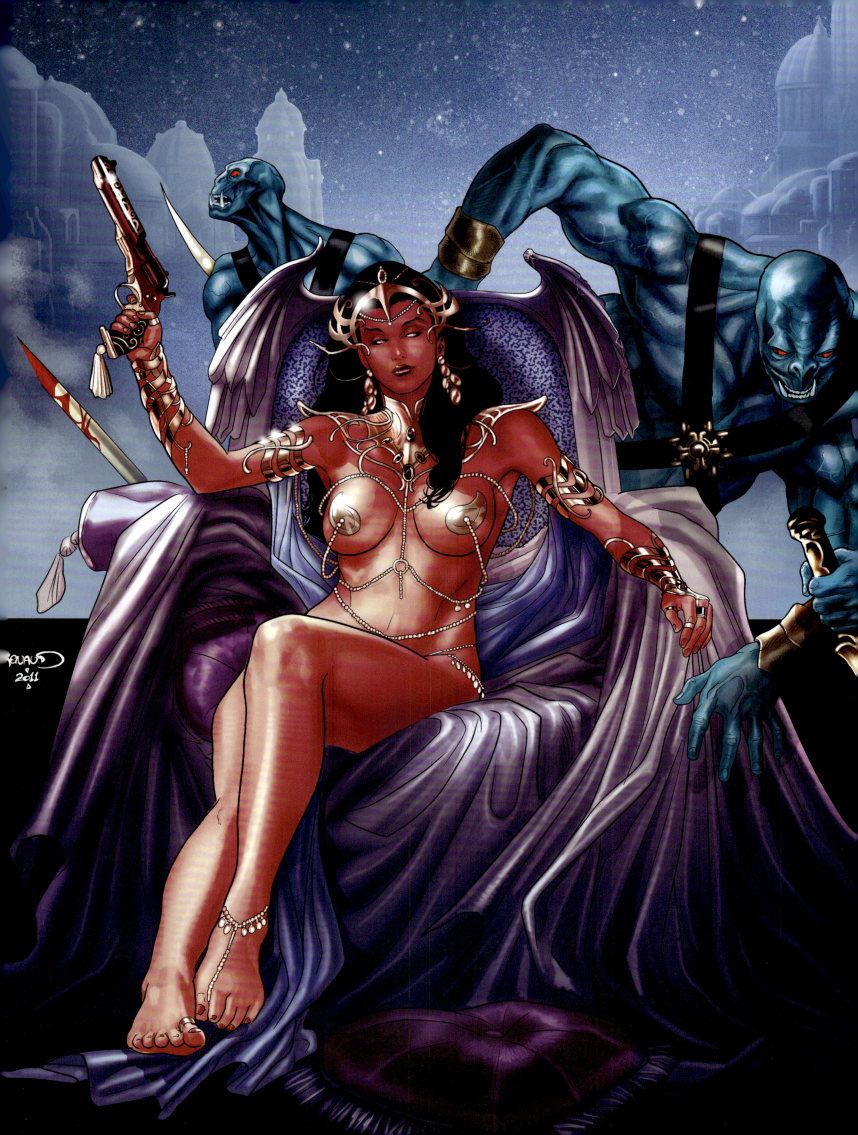

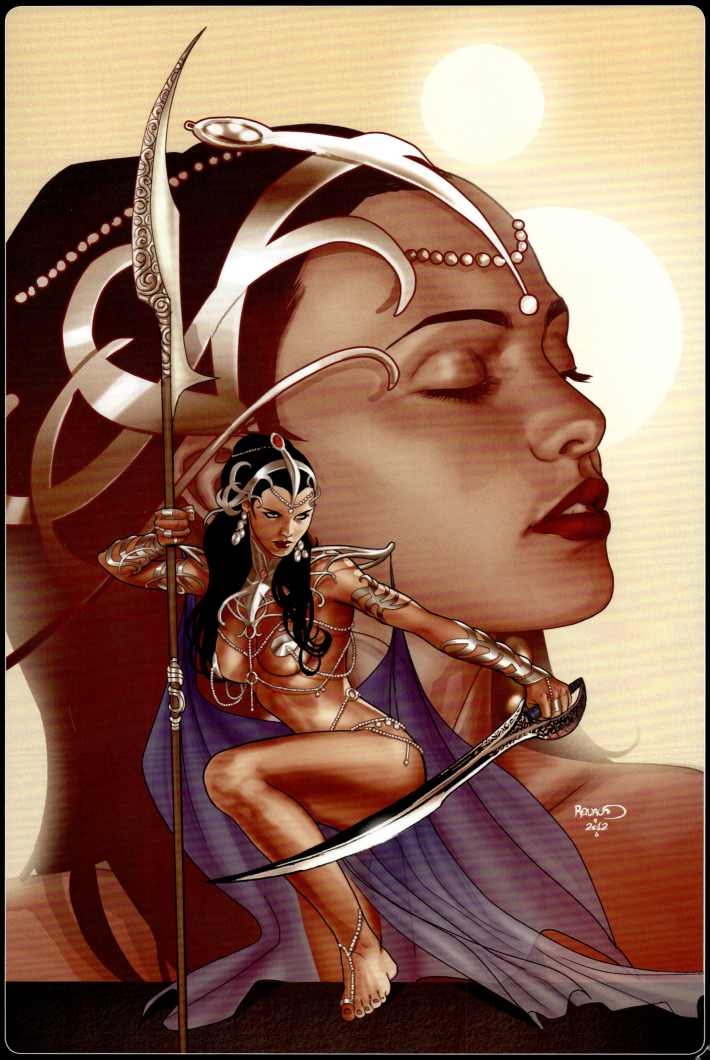

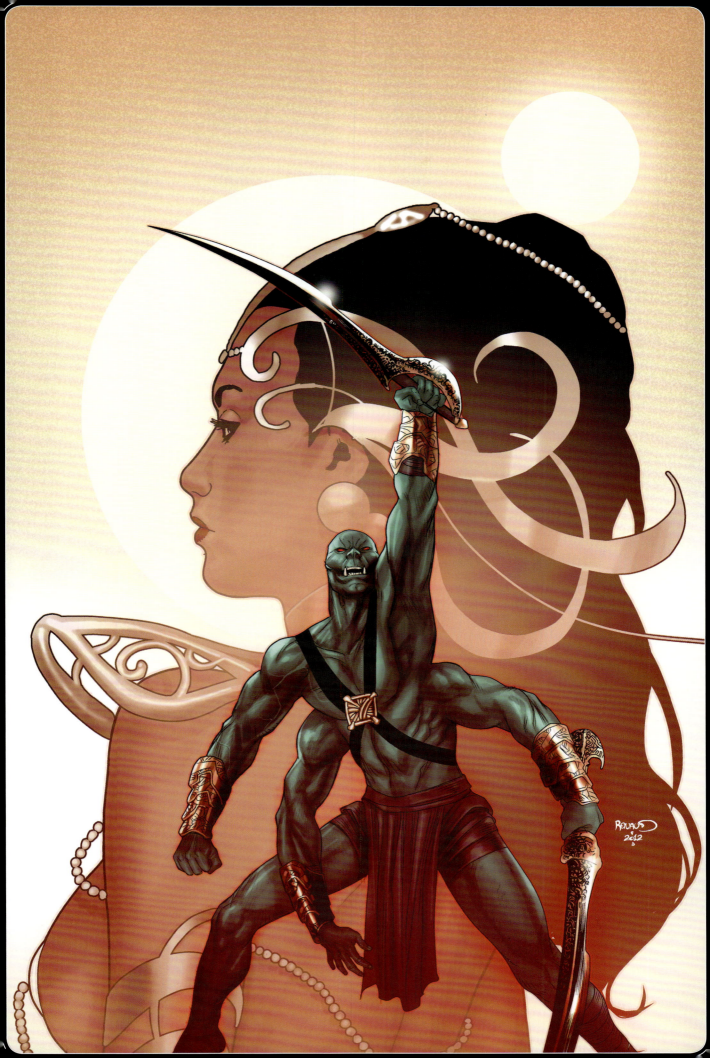

VAMPIRELLA

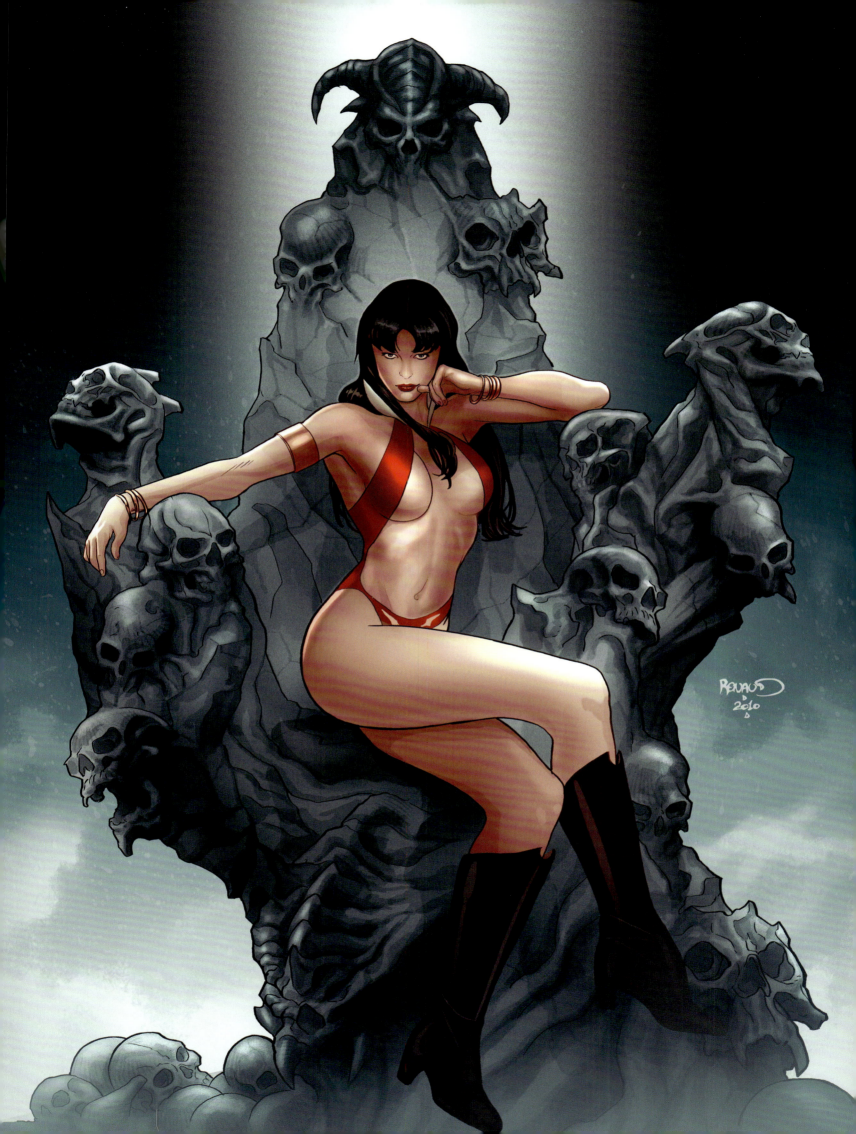

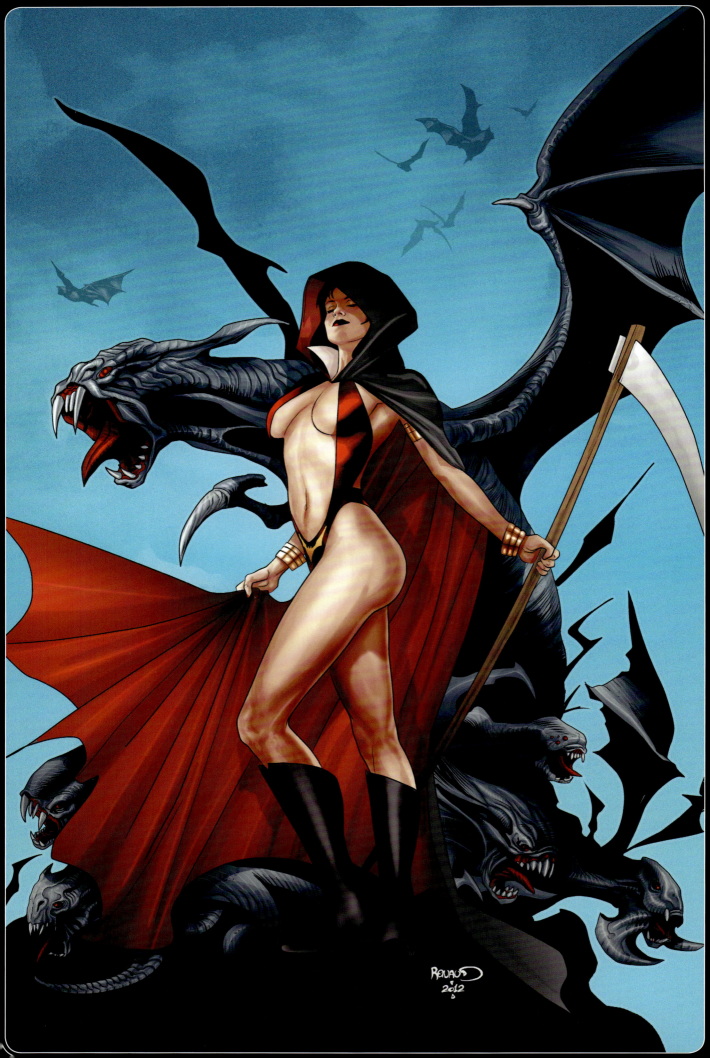

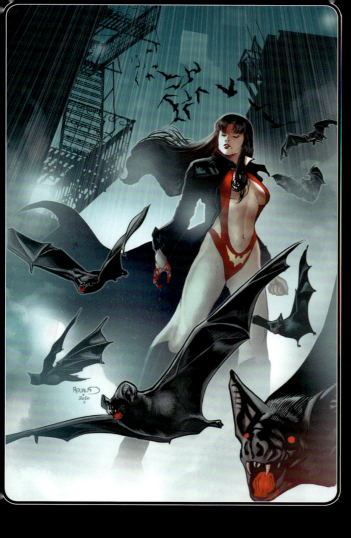
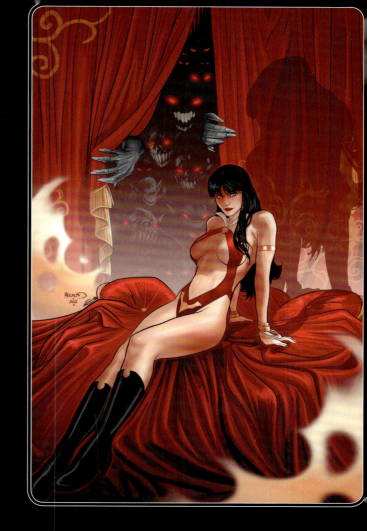
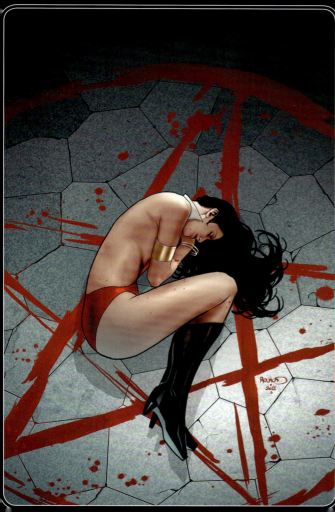
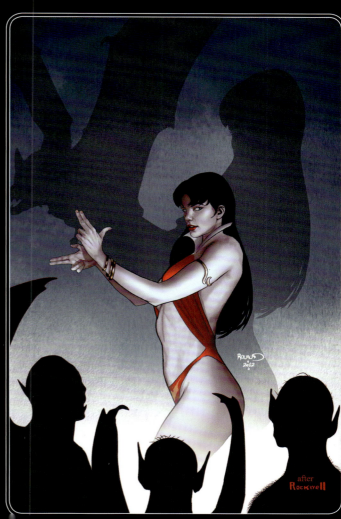

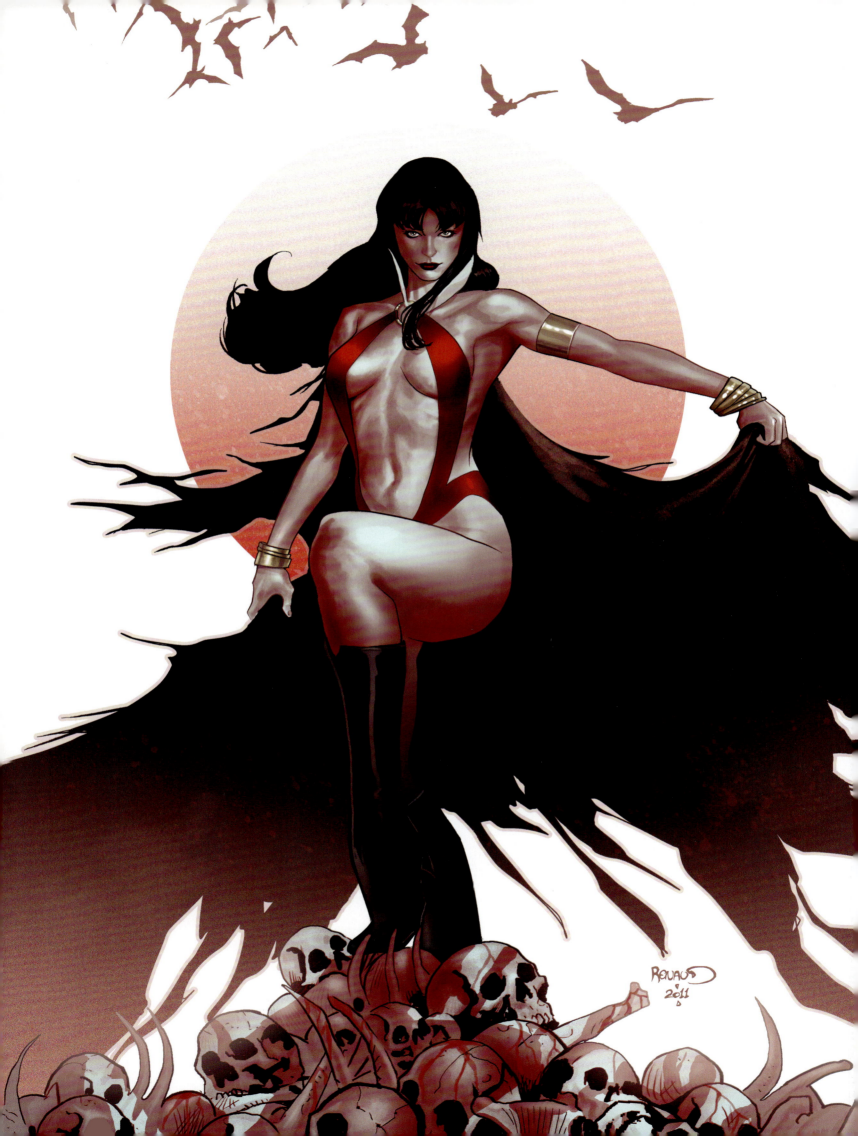

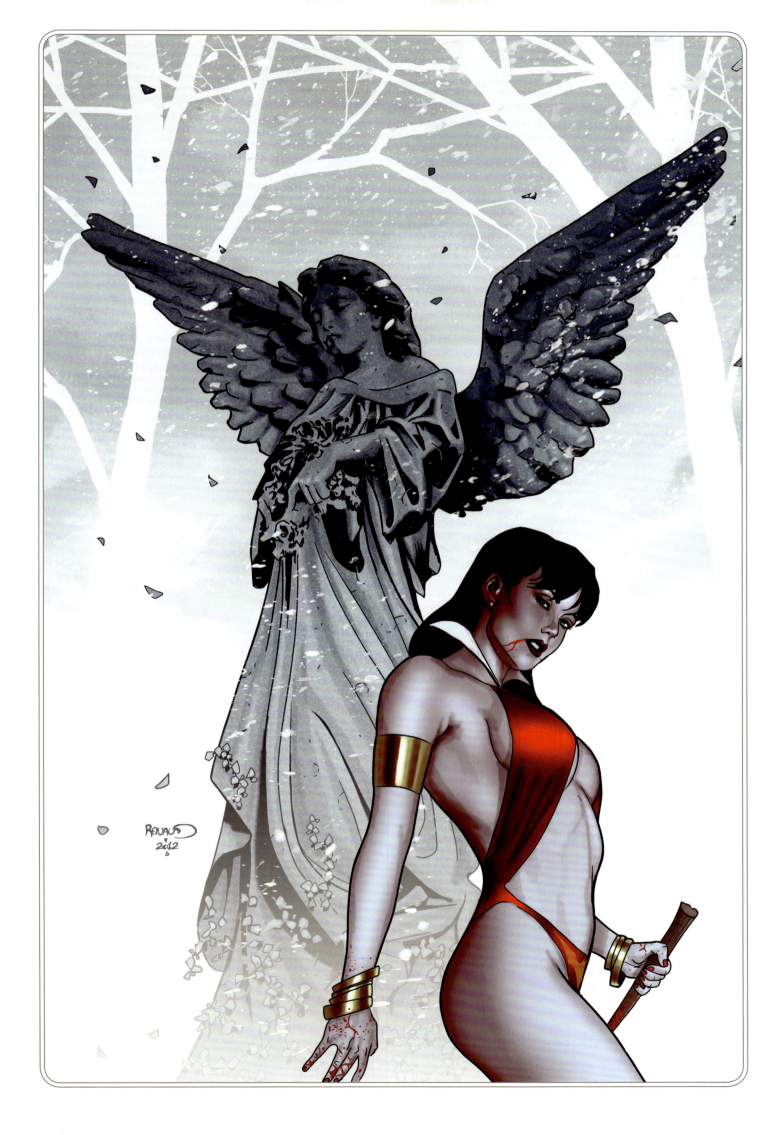

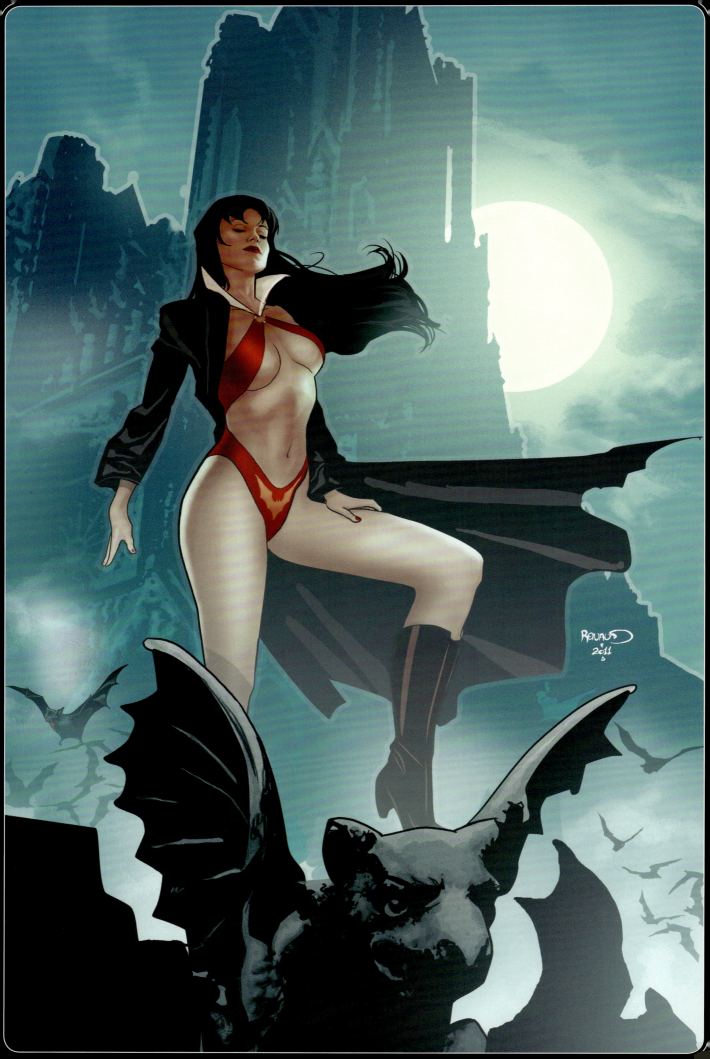

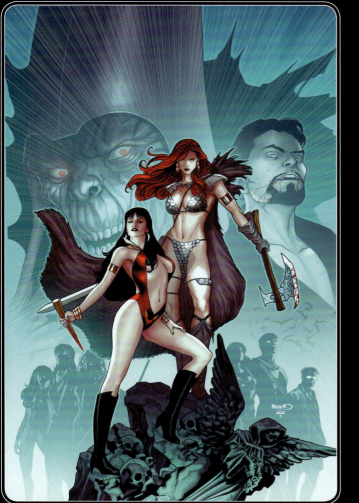
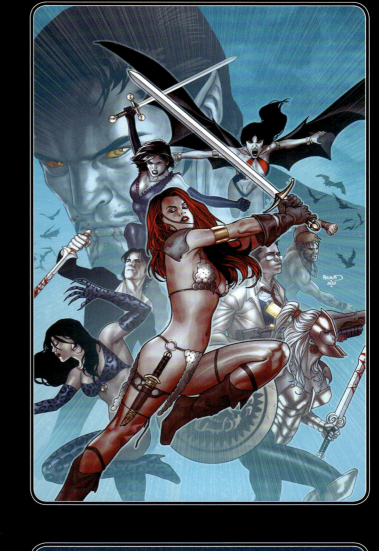
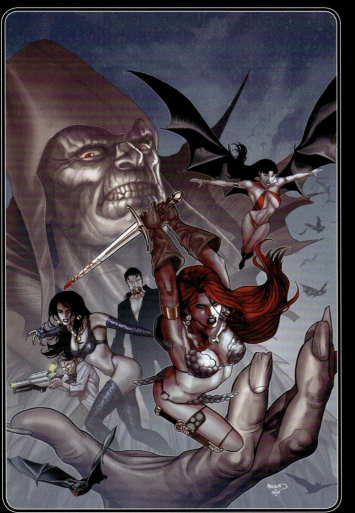
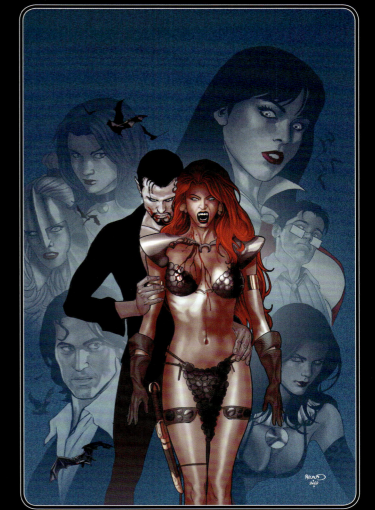

PROPHECY

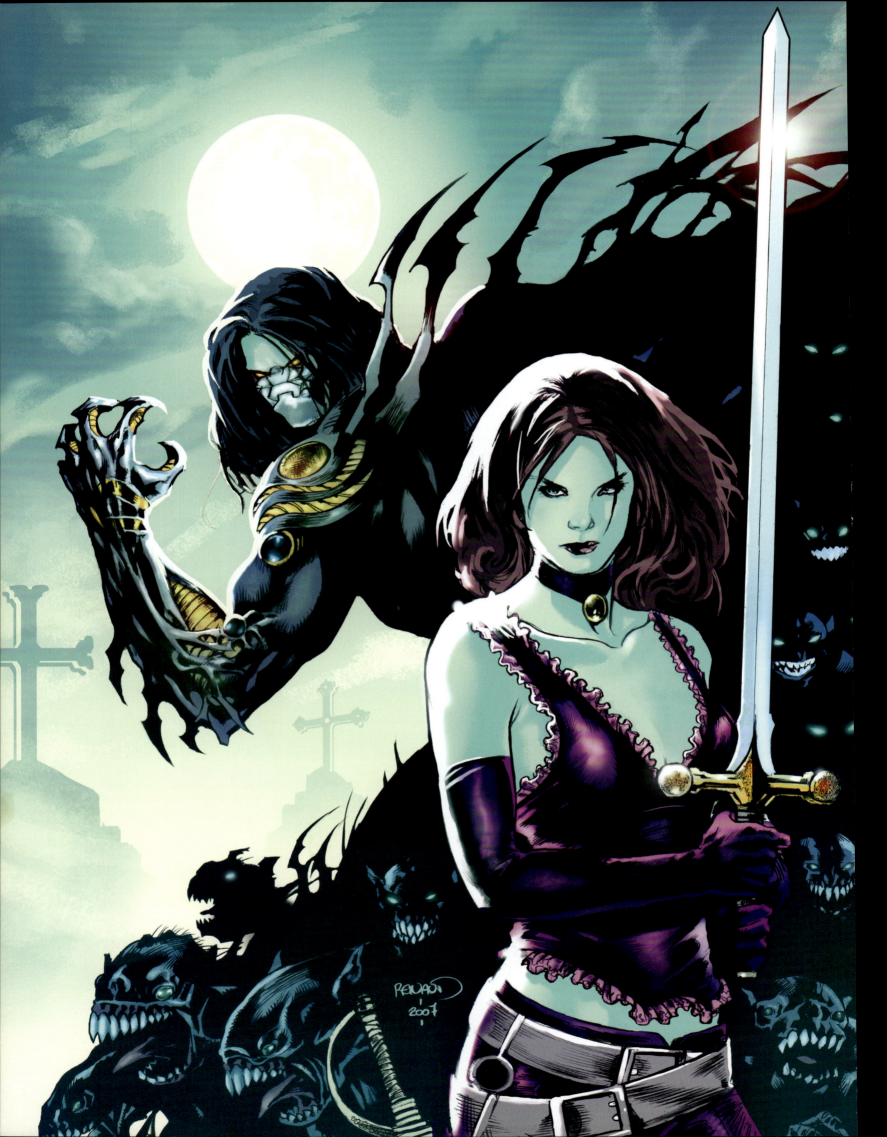

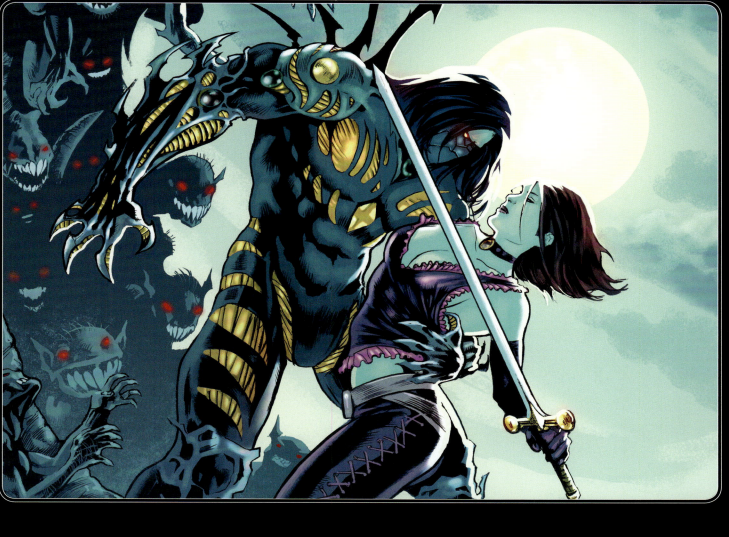
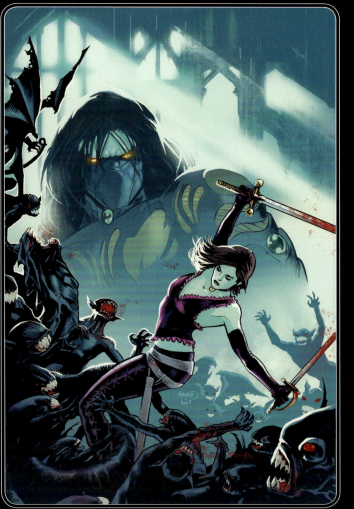
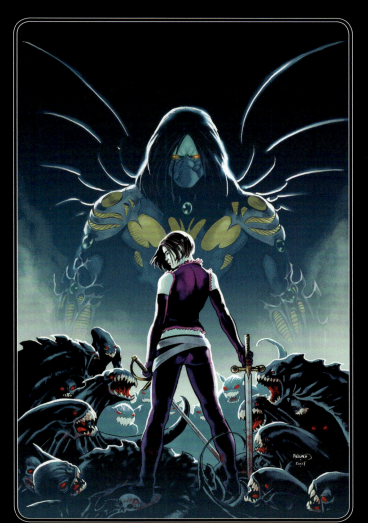

DARKNESS vs EVA

STAR WARS

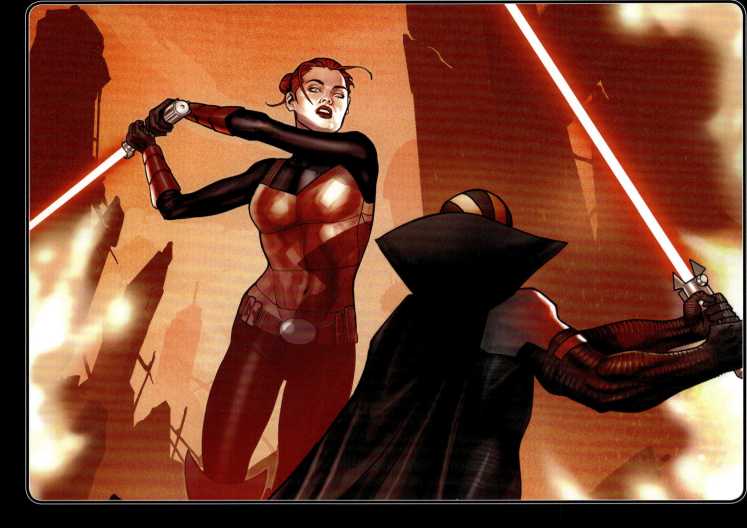
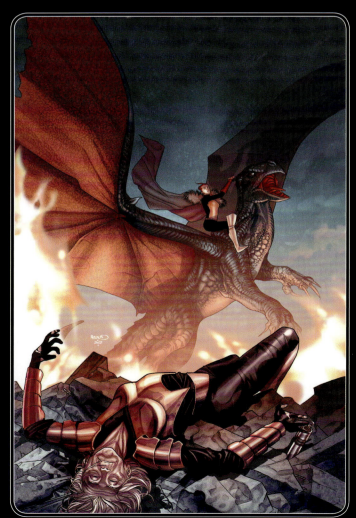
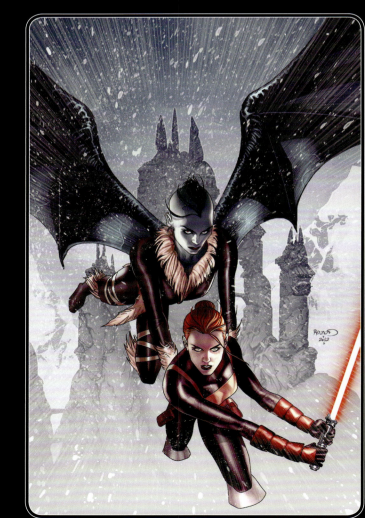

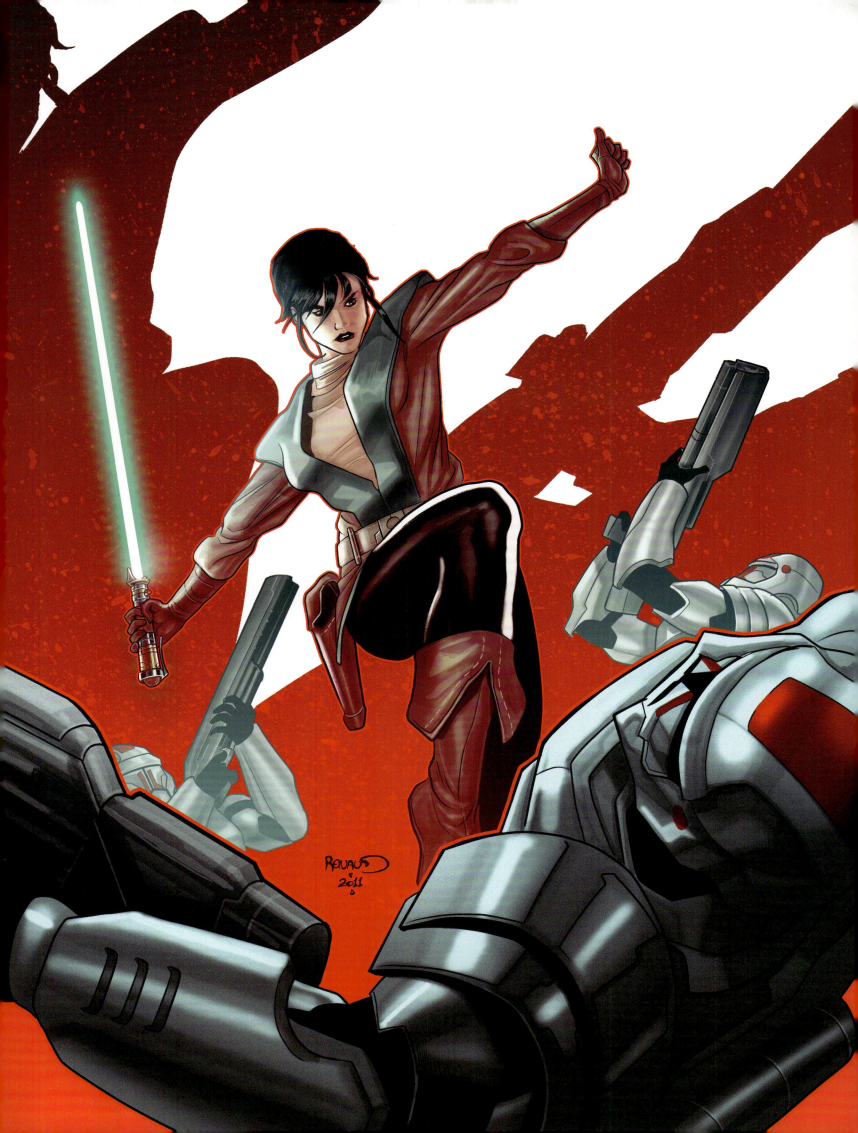

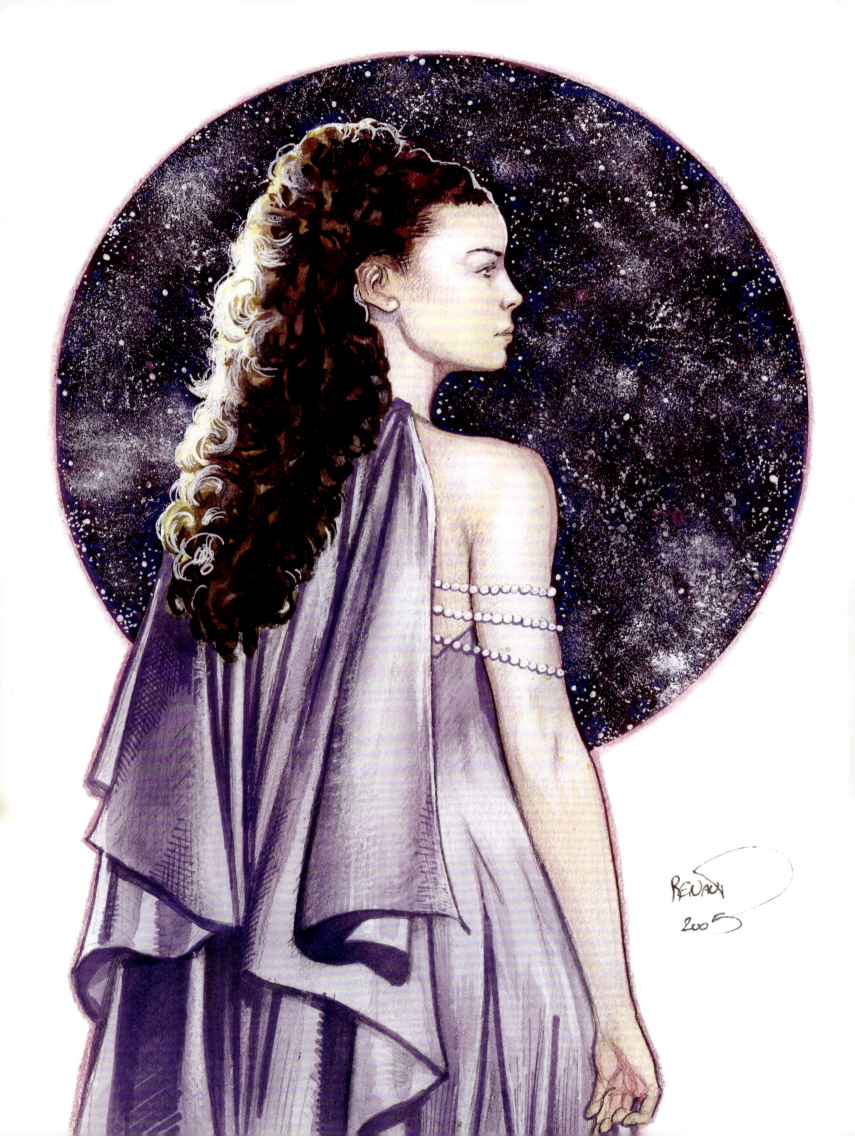

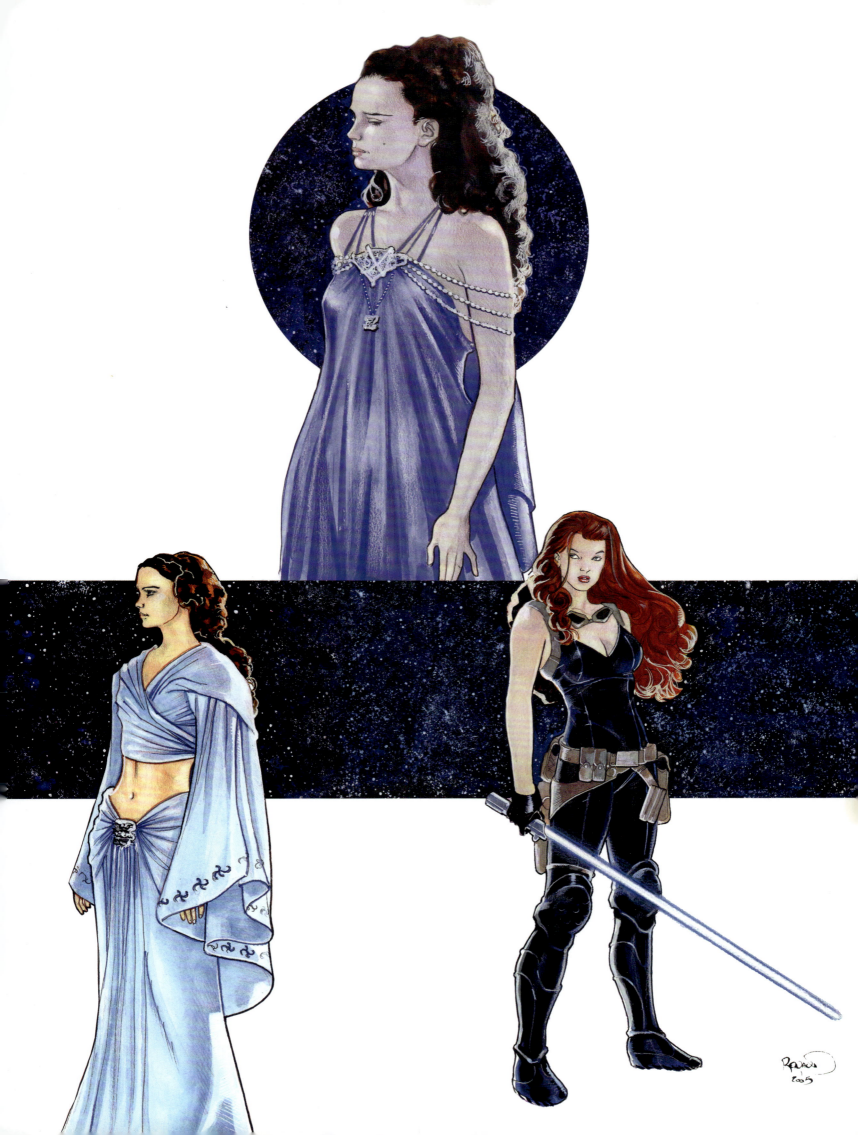

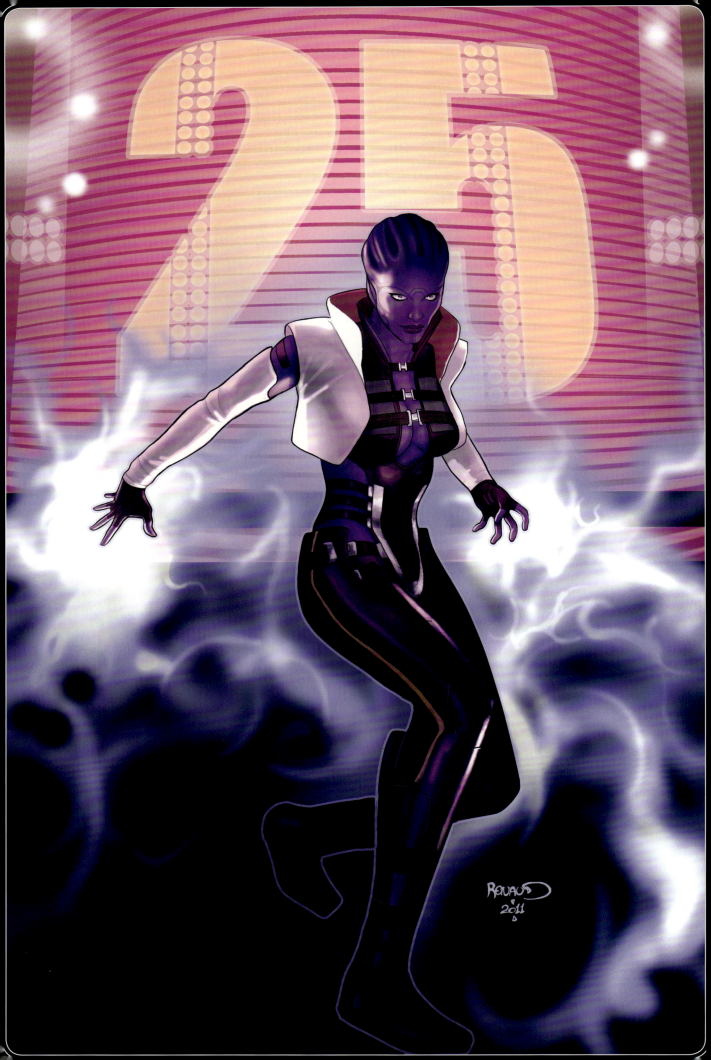

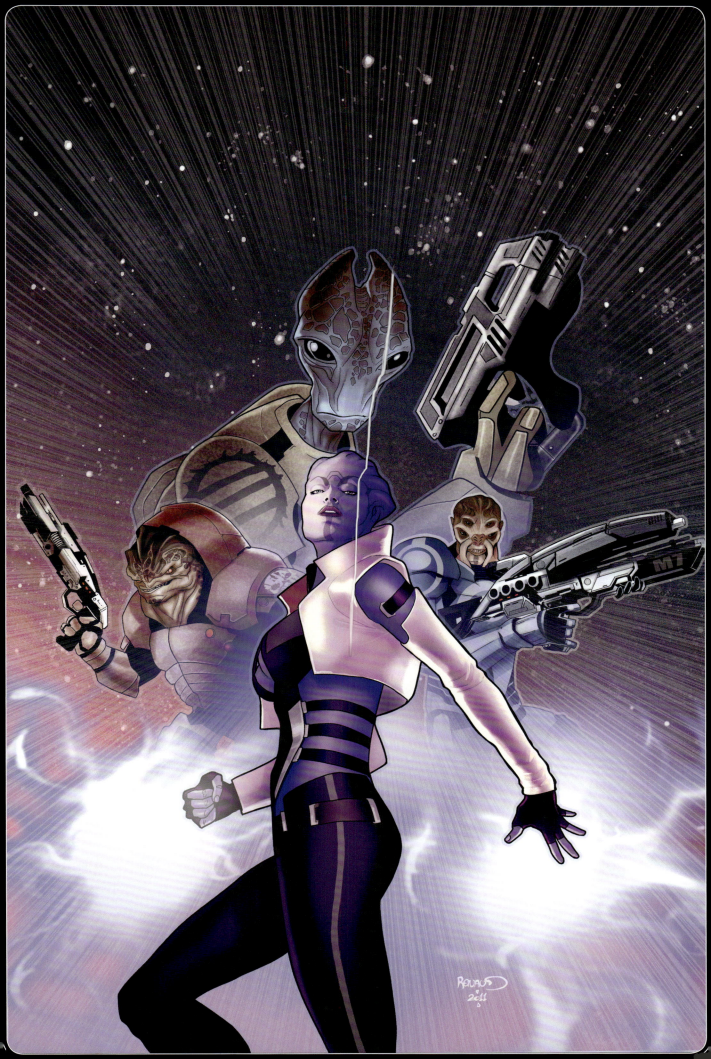

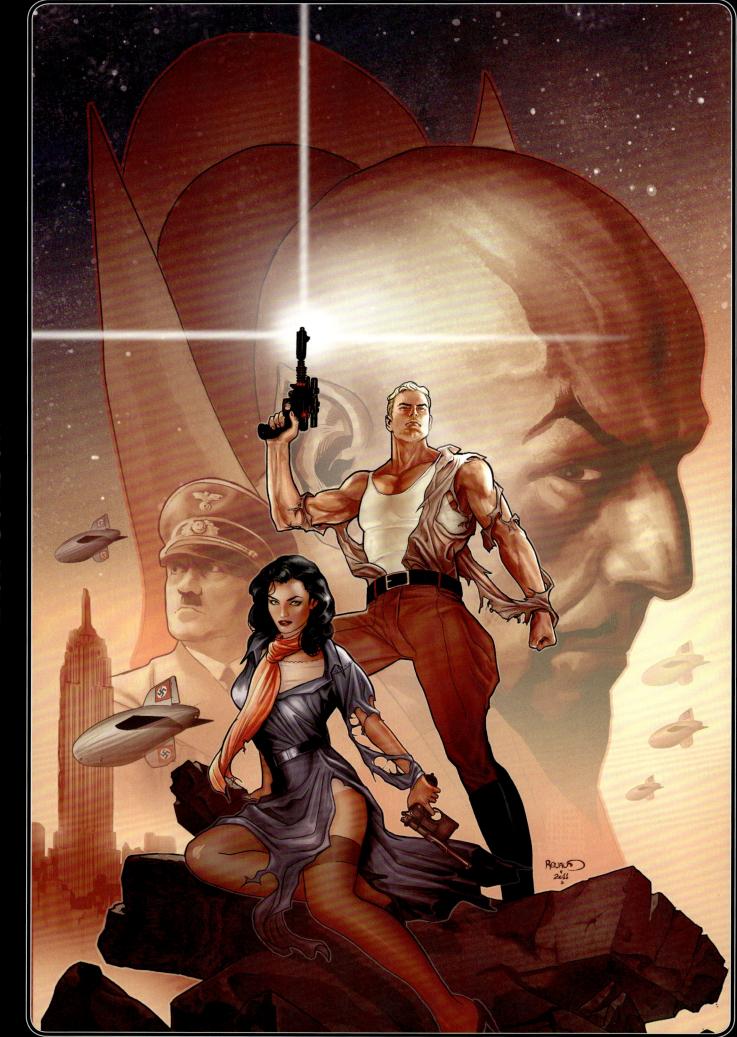
Flash Gordon

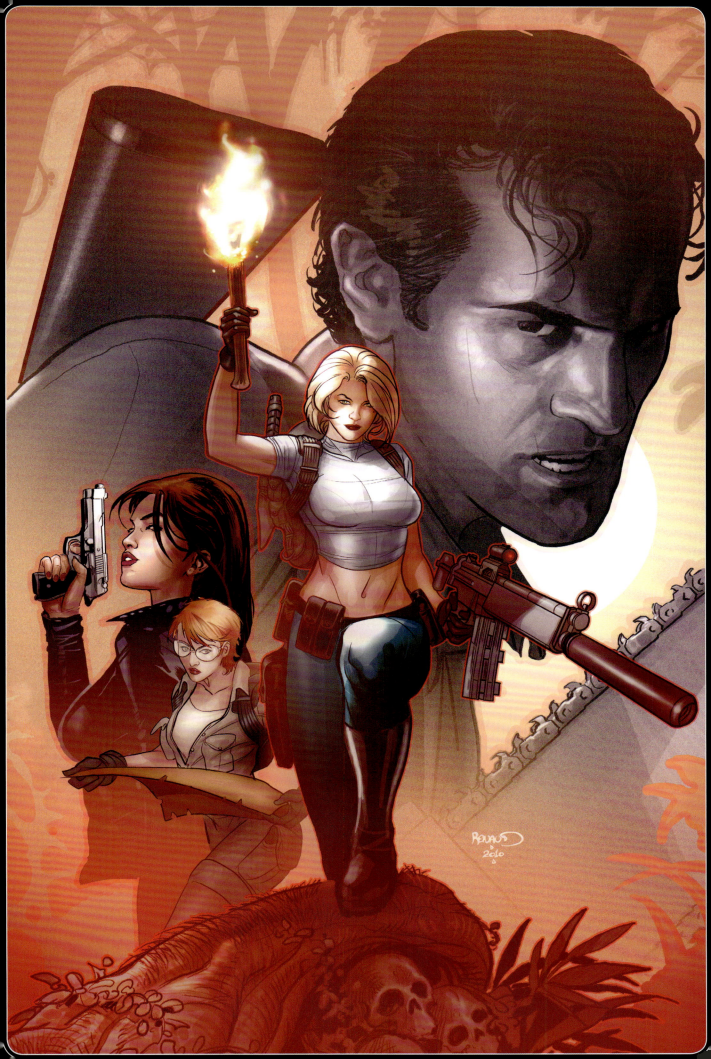

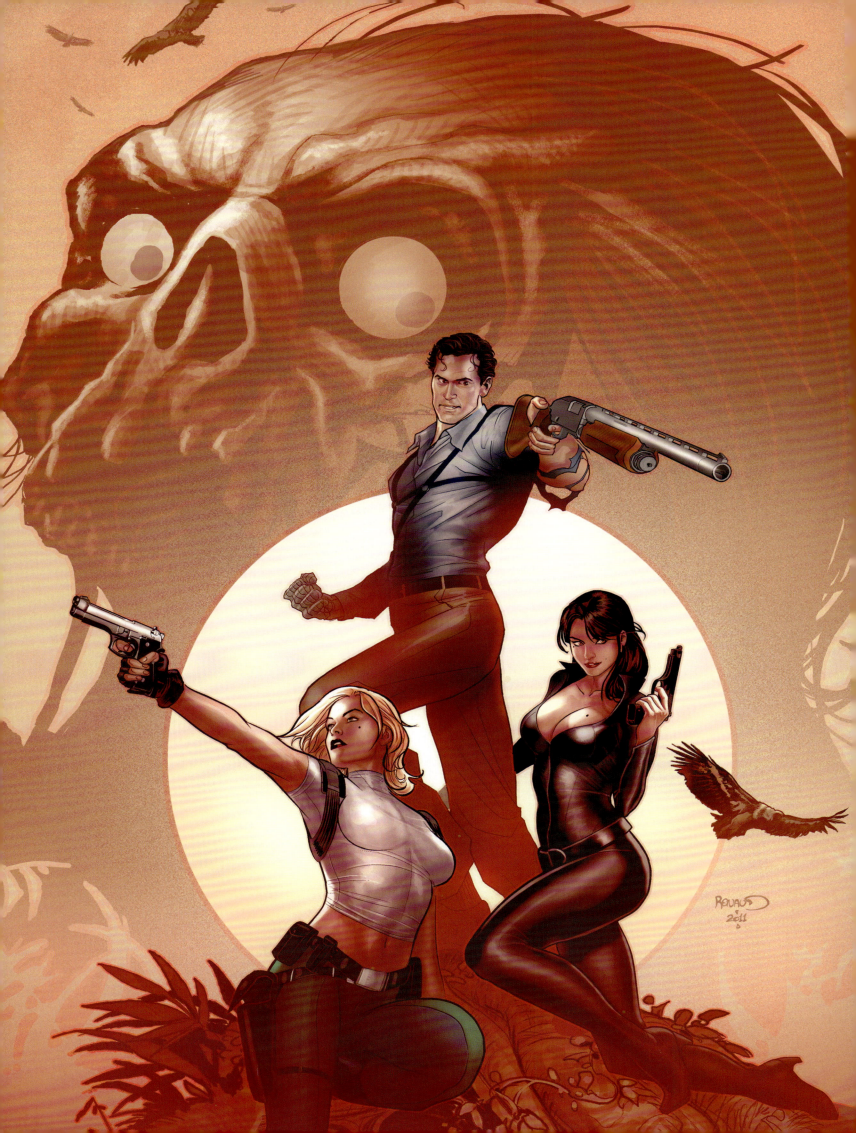

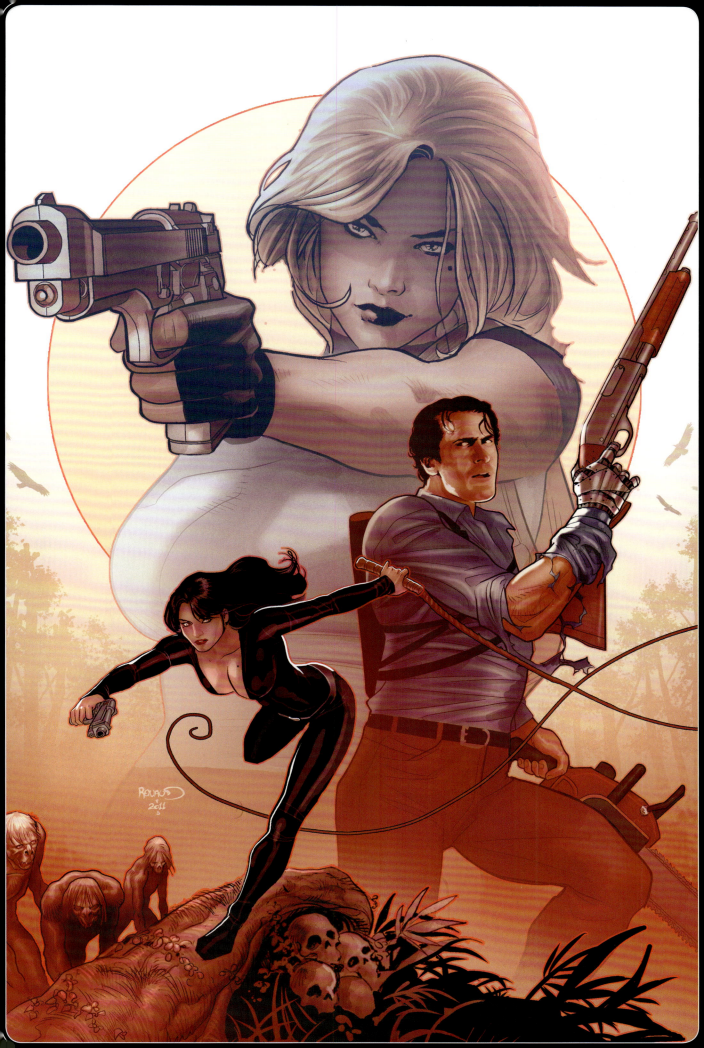

Green Hornet

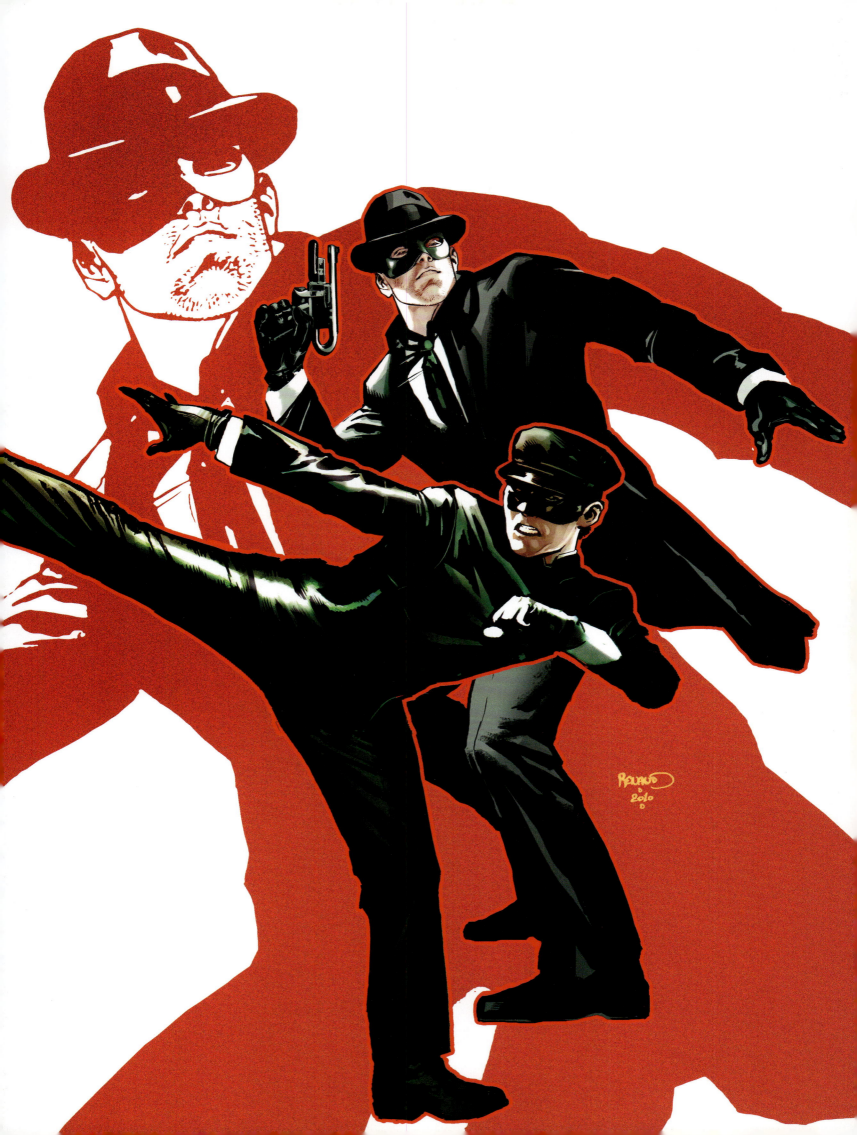

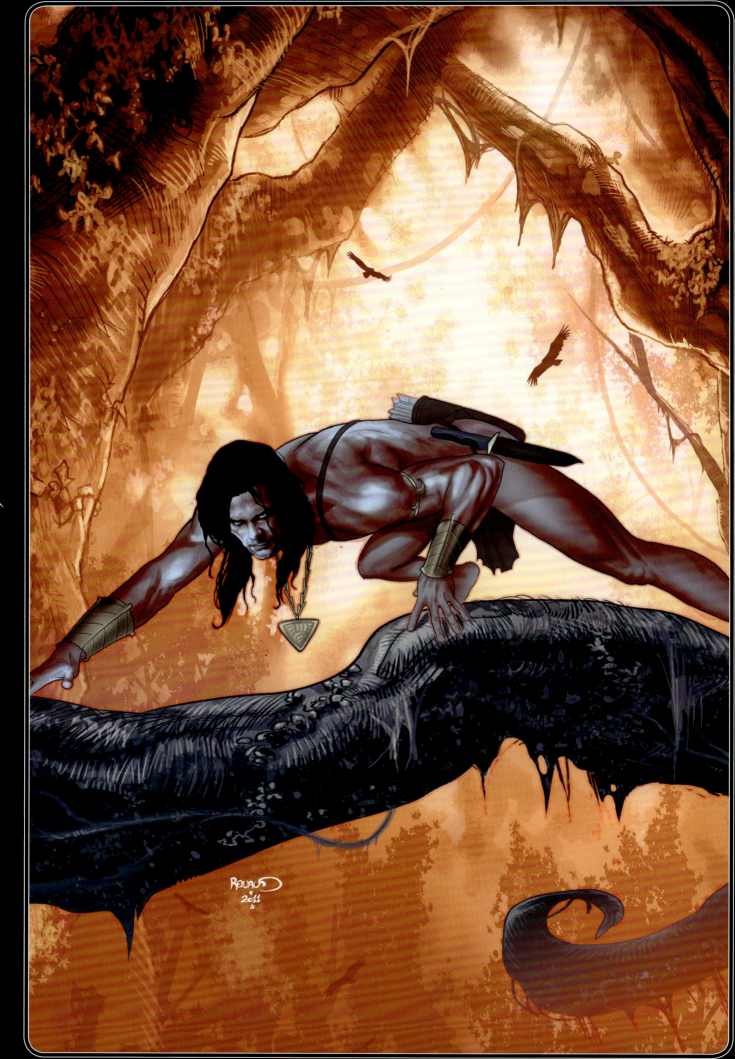

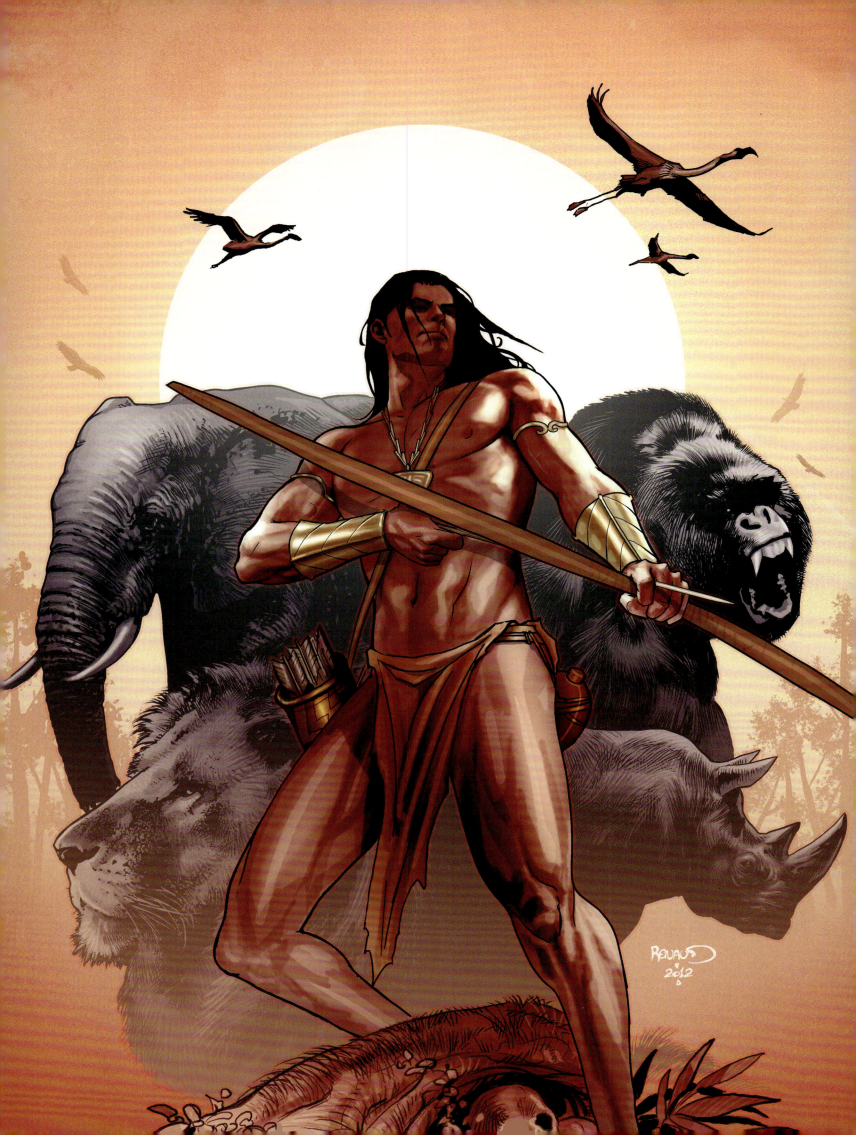

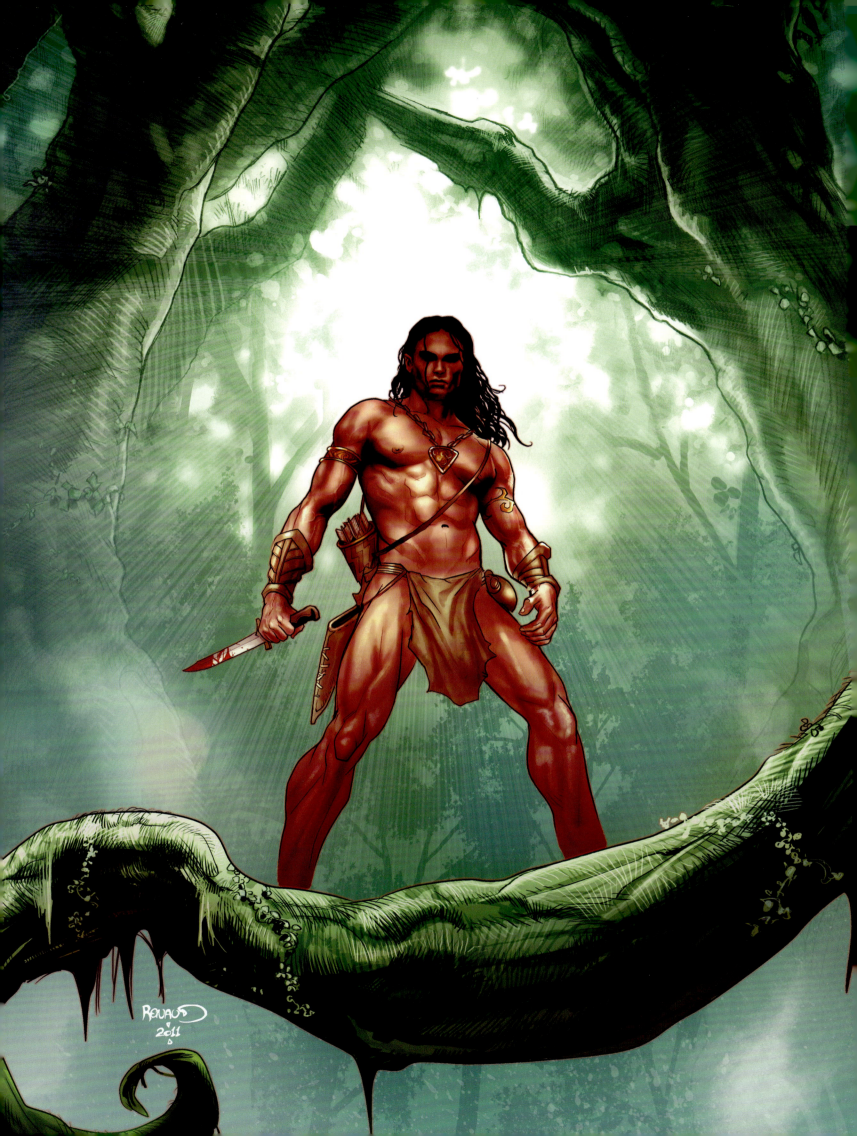

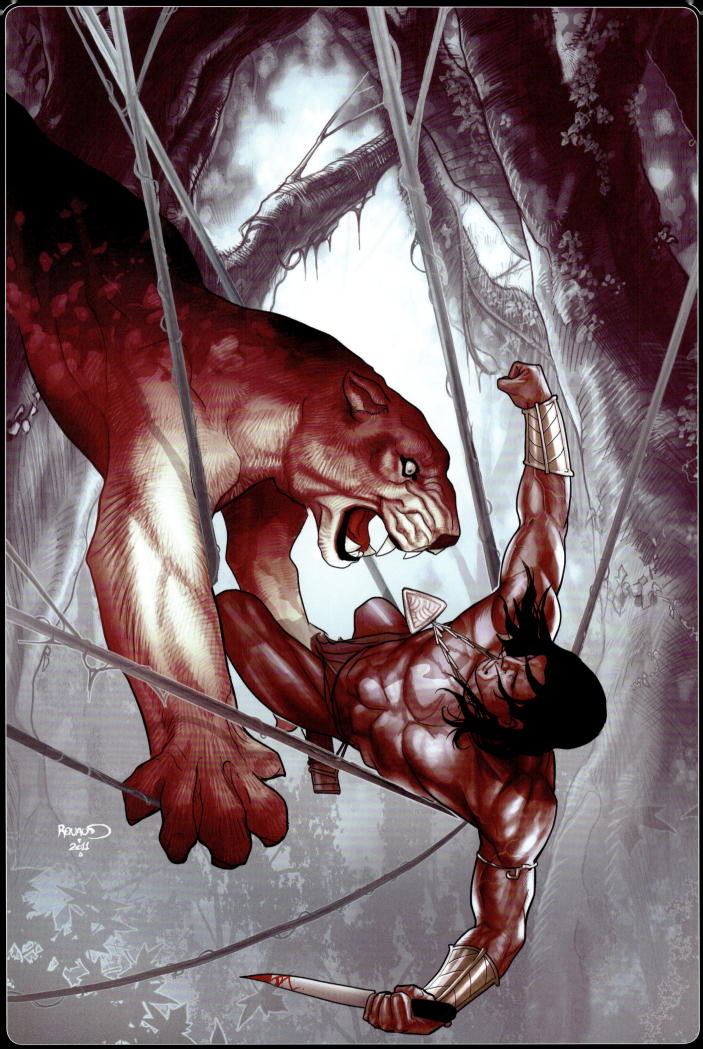

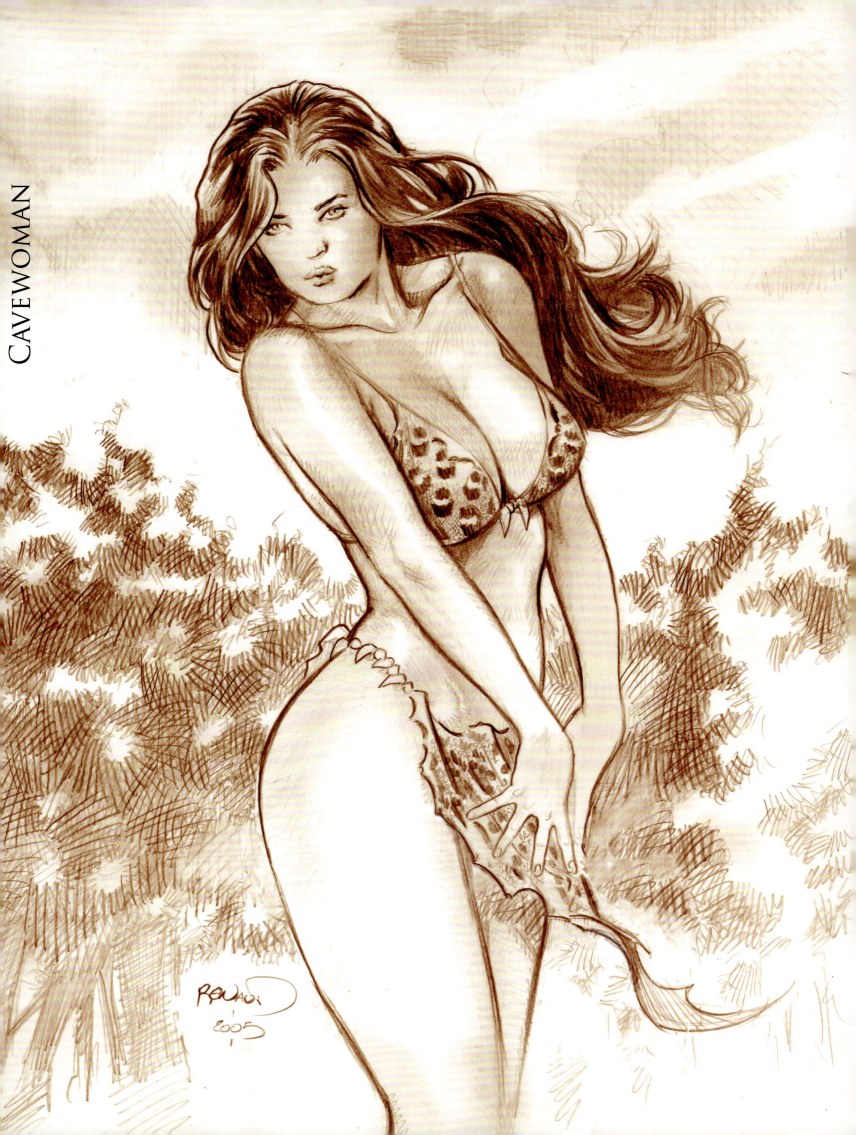

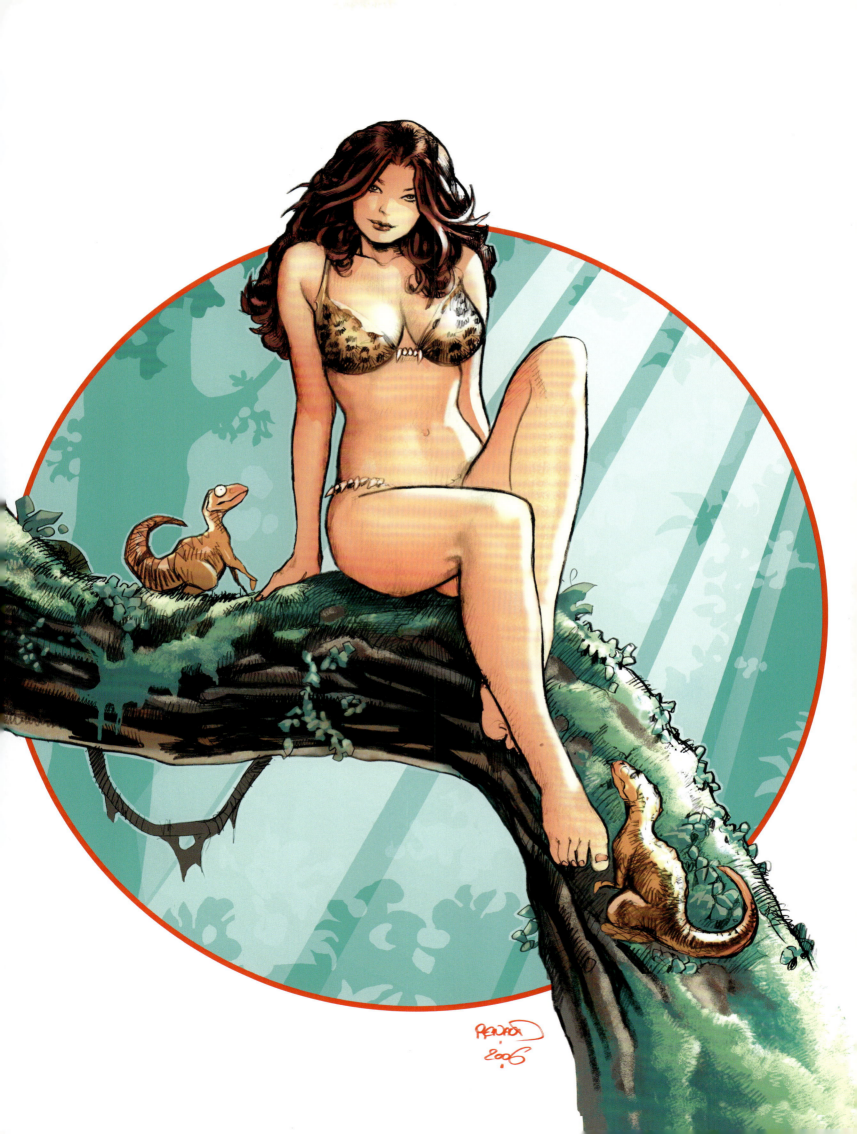

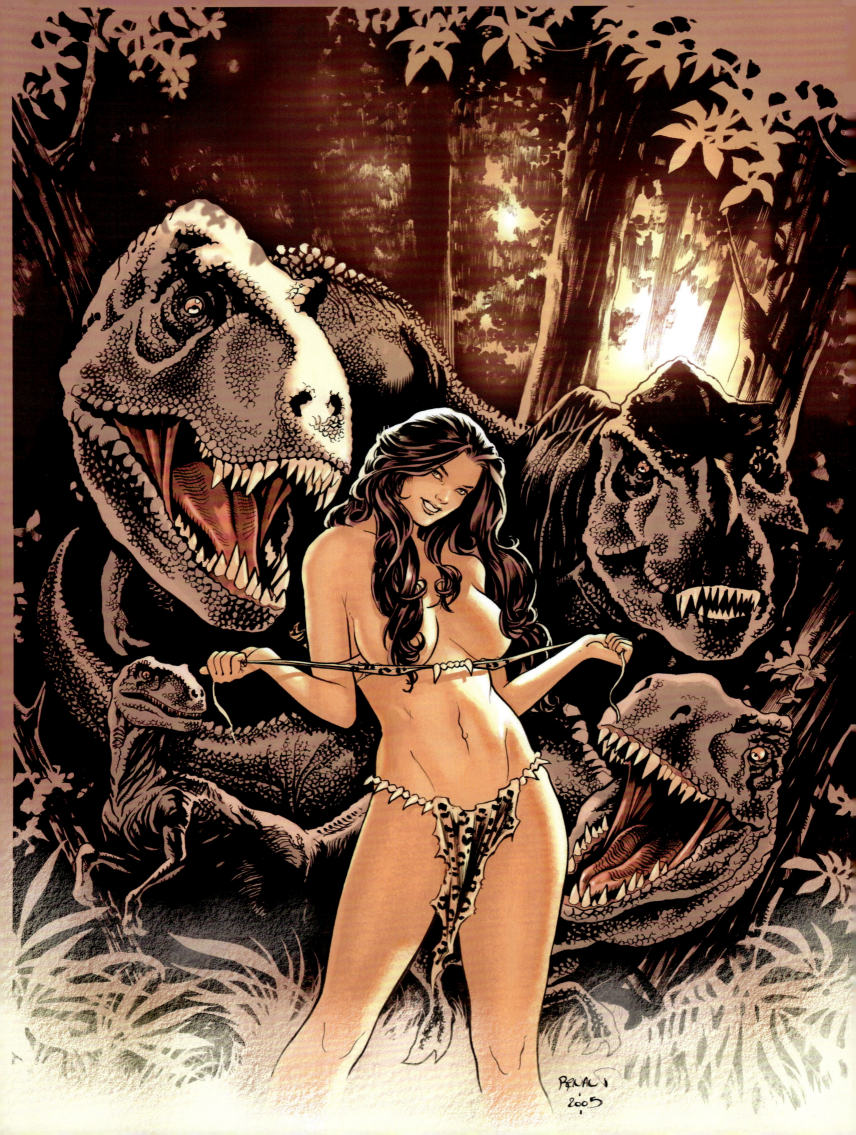

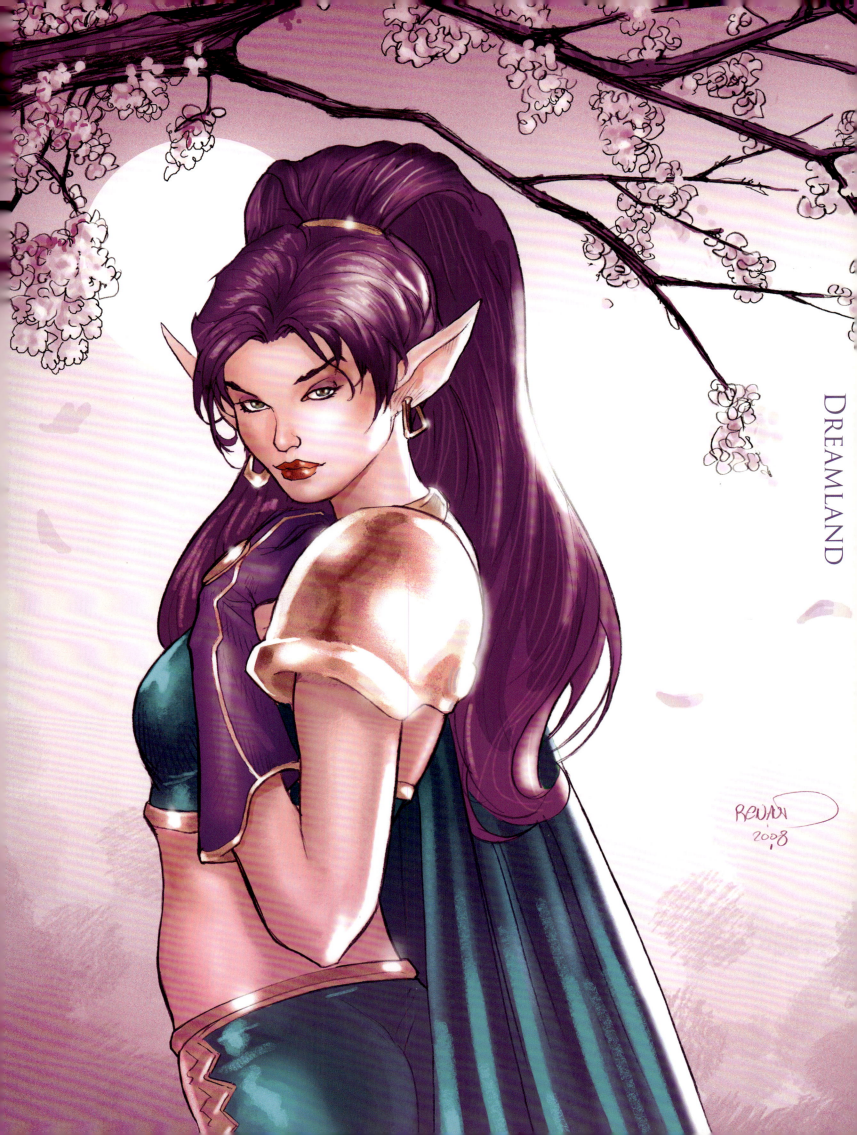

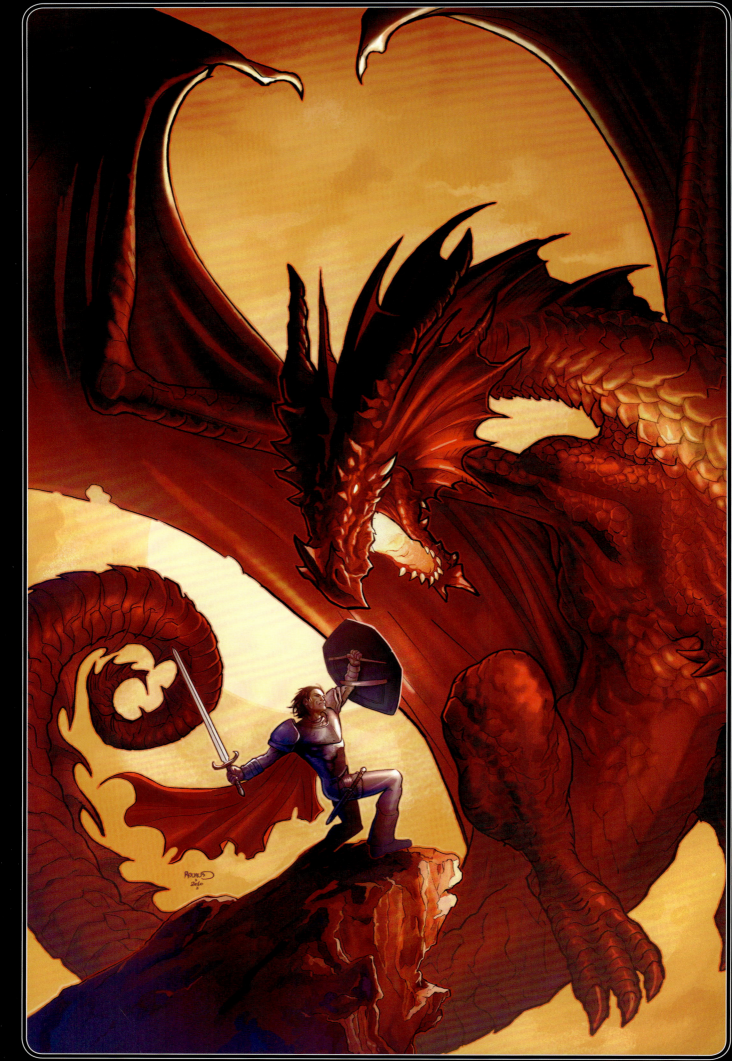

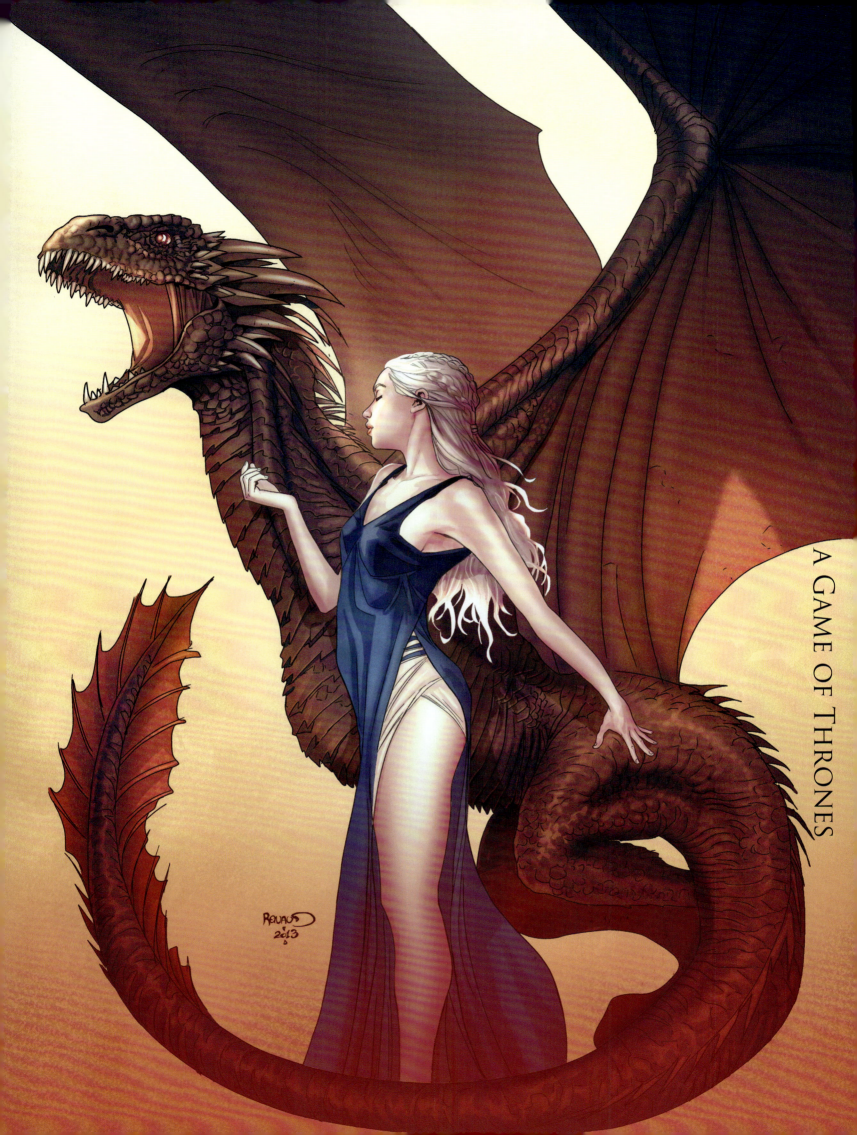

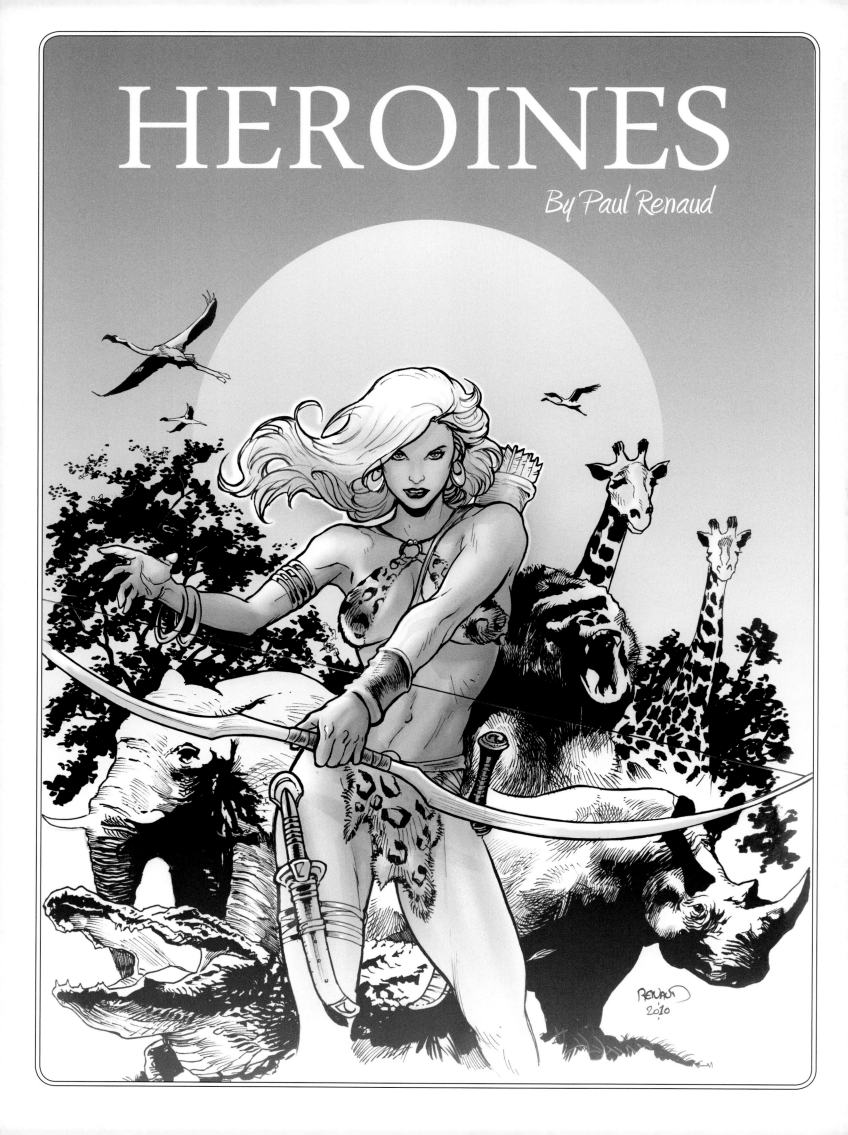

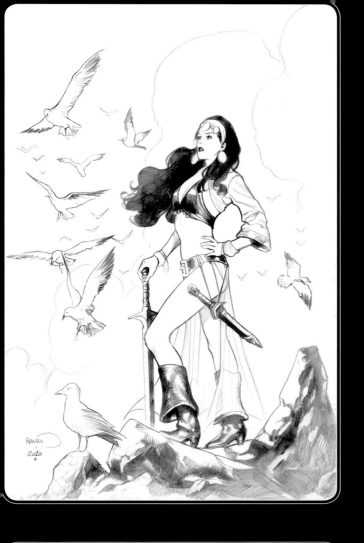
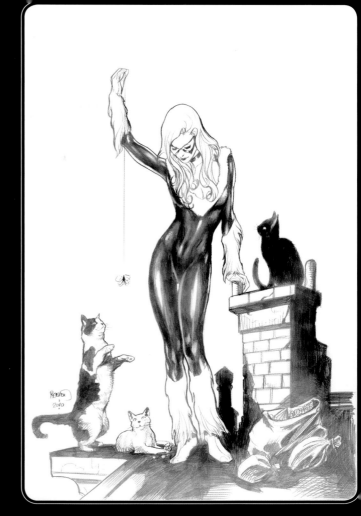
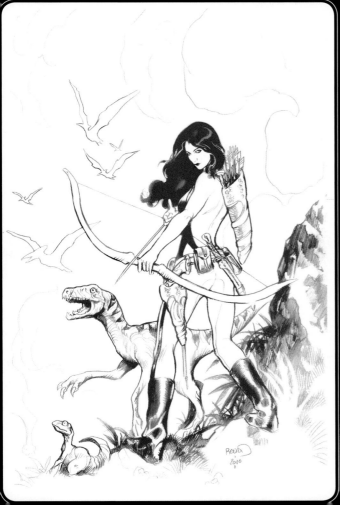
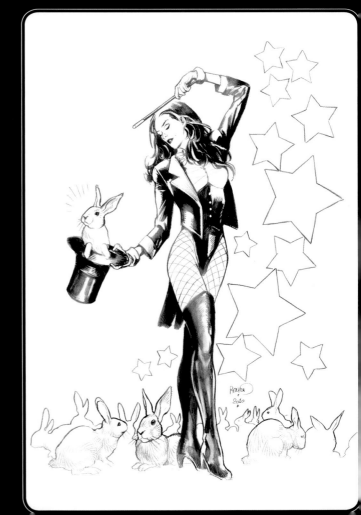

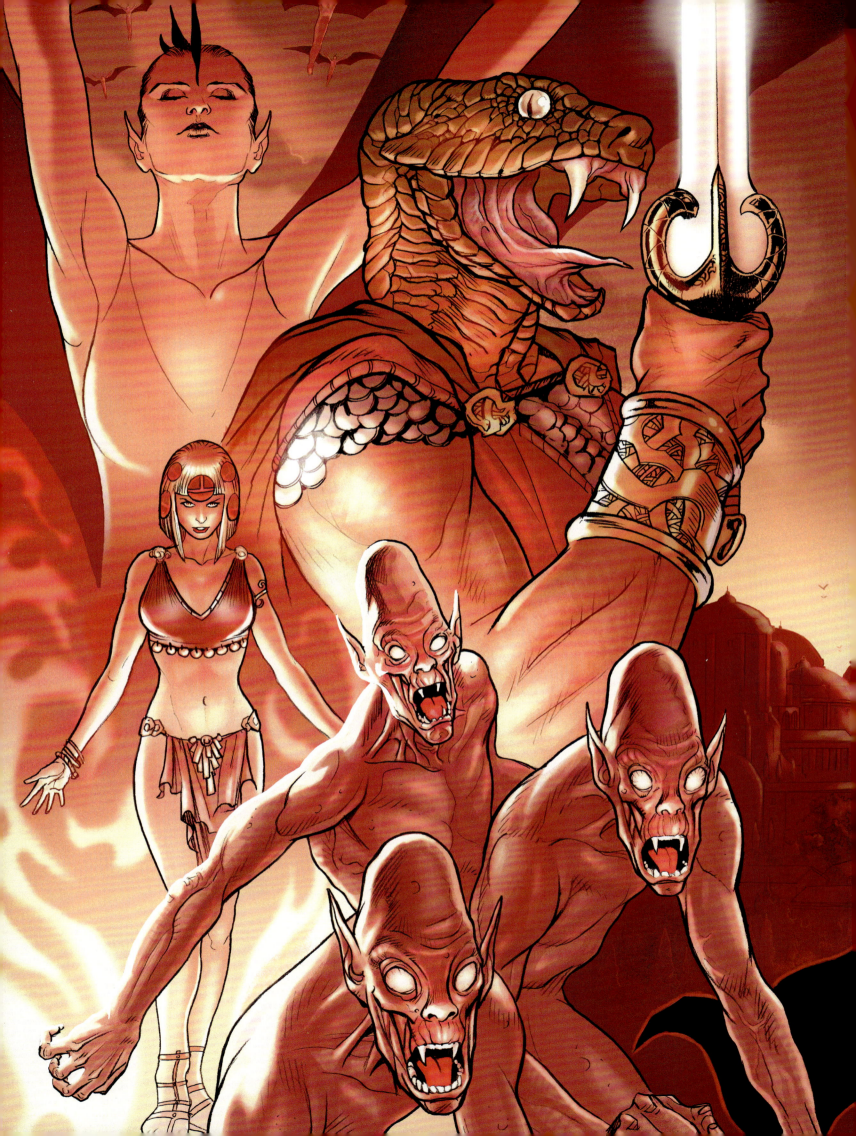

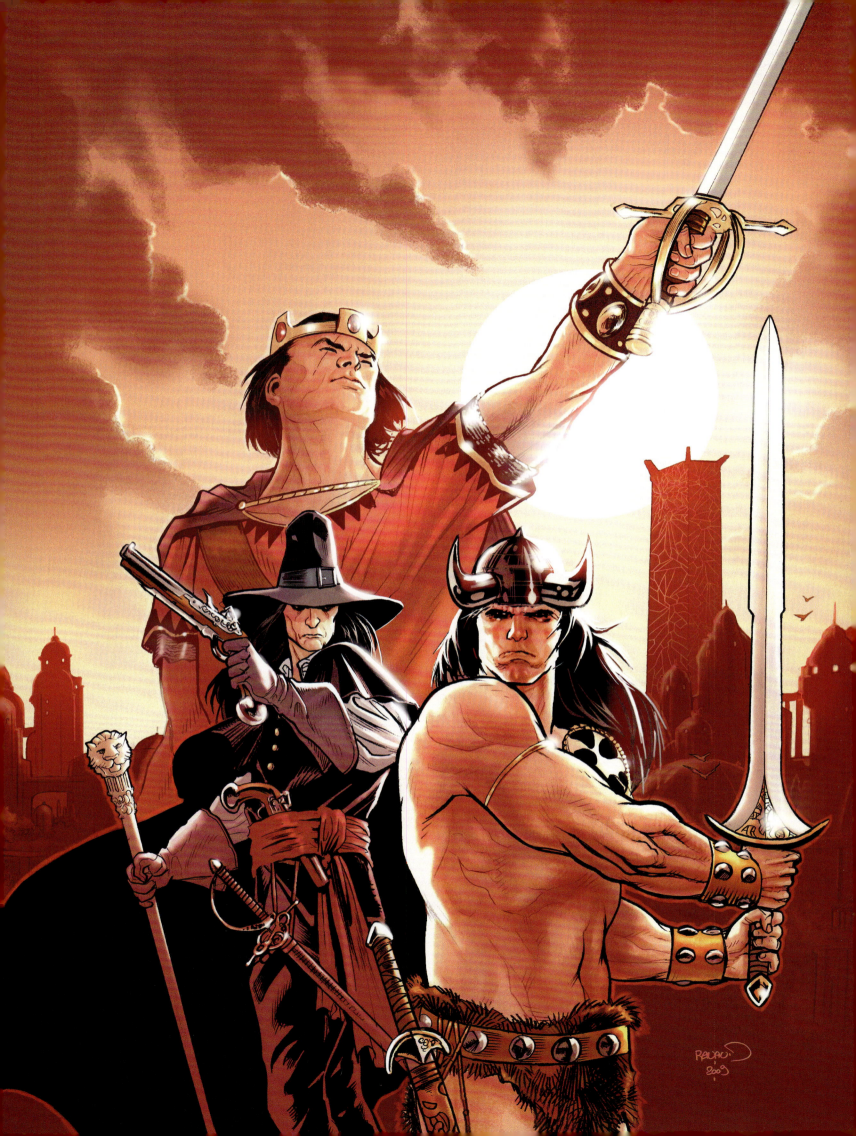

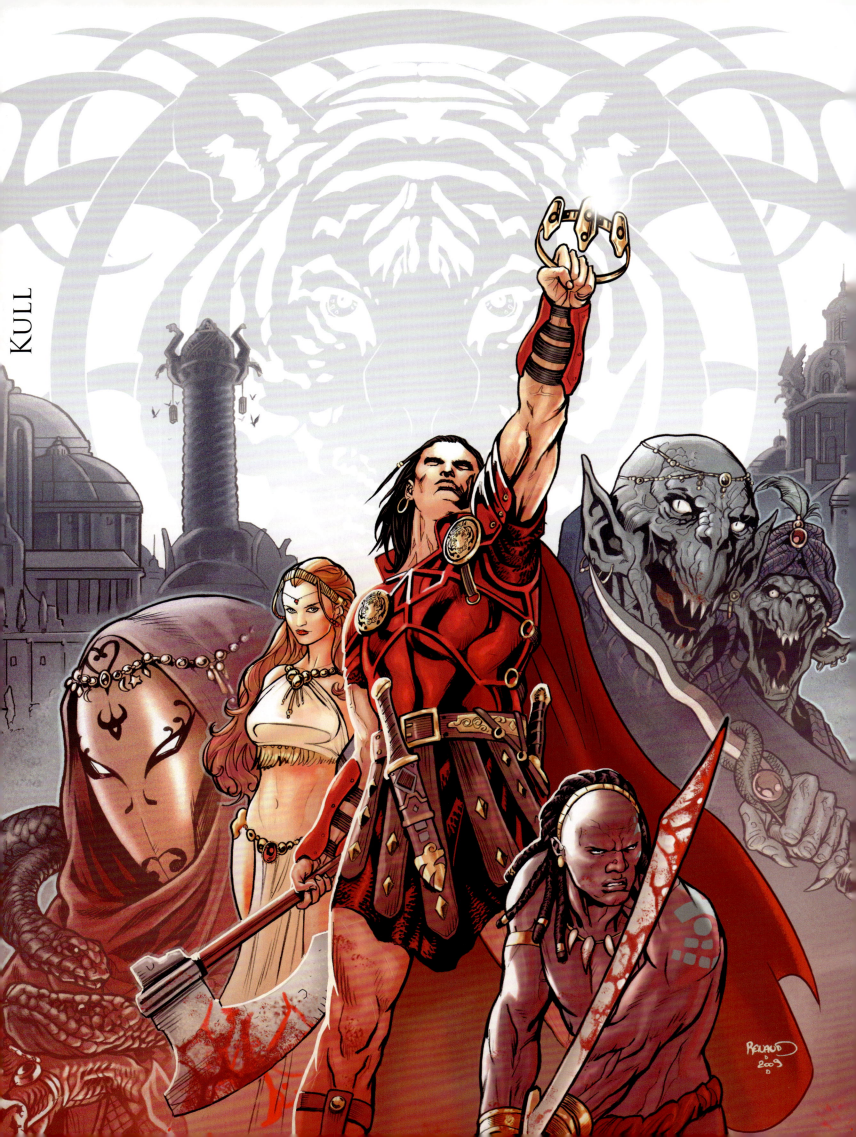
KULL

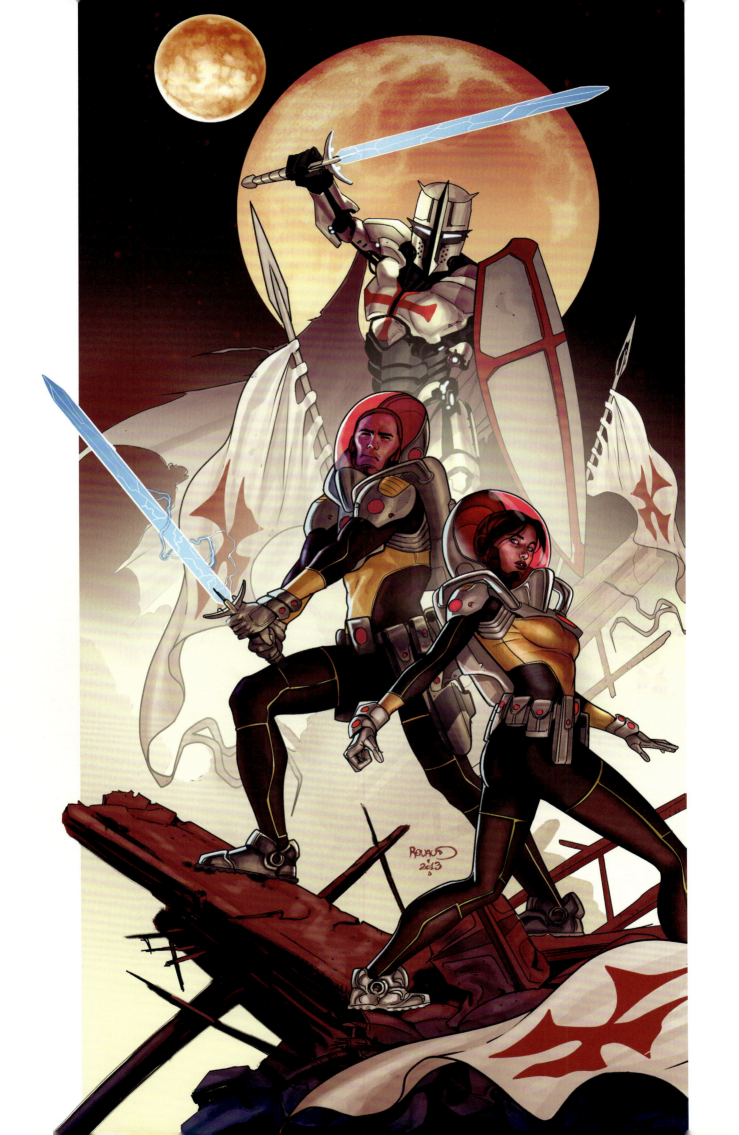

BLACK SCIENCE

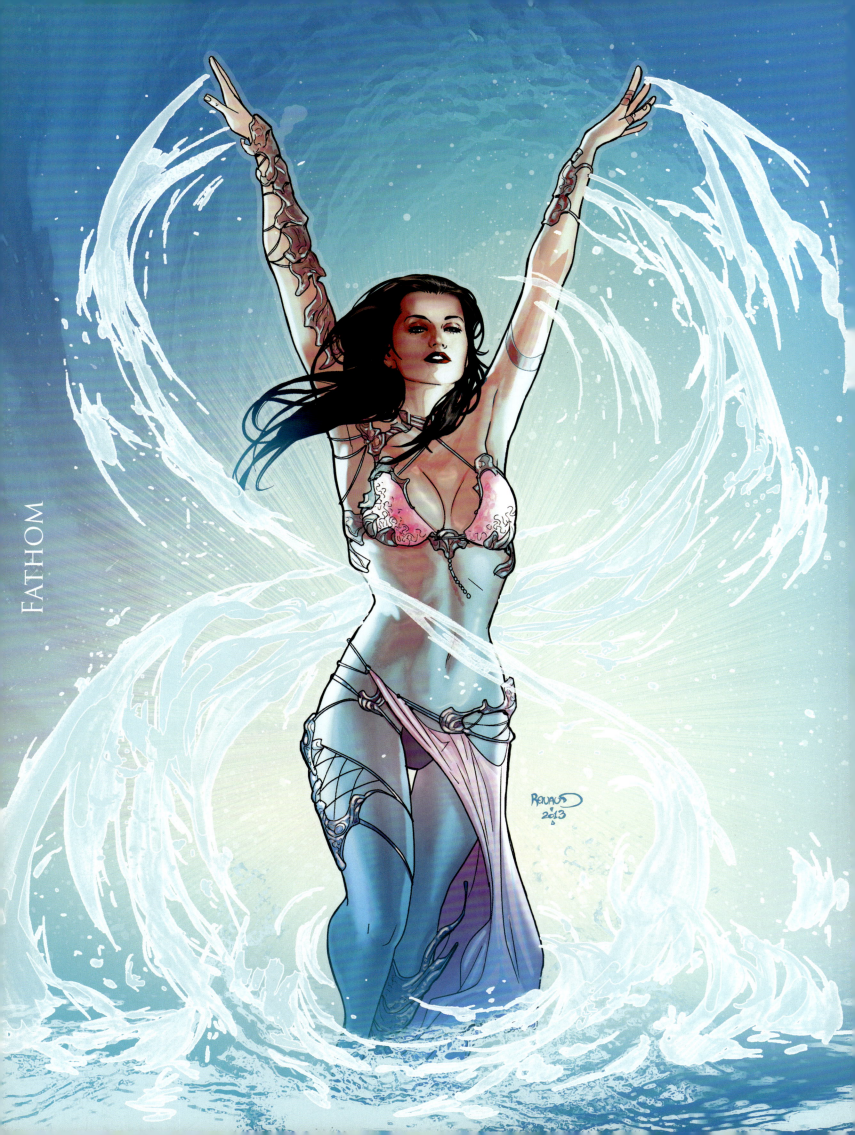

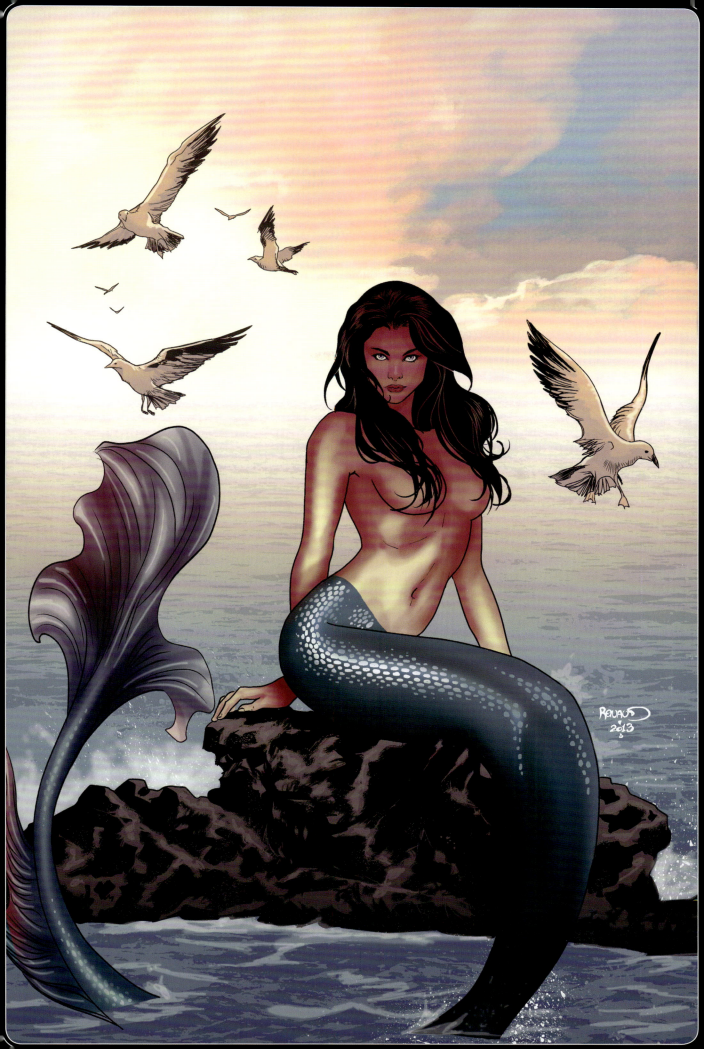

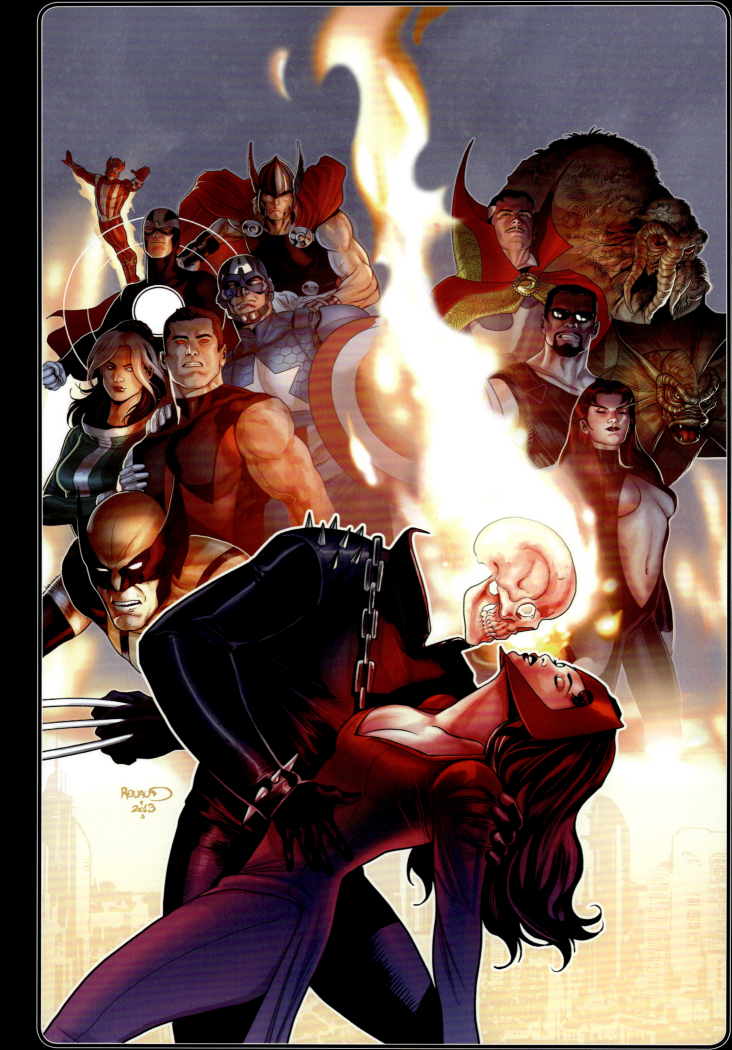

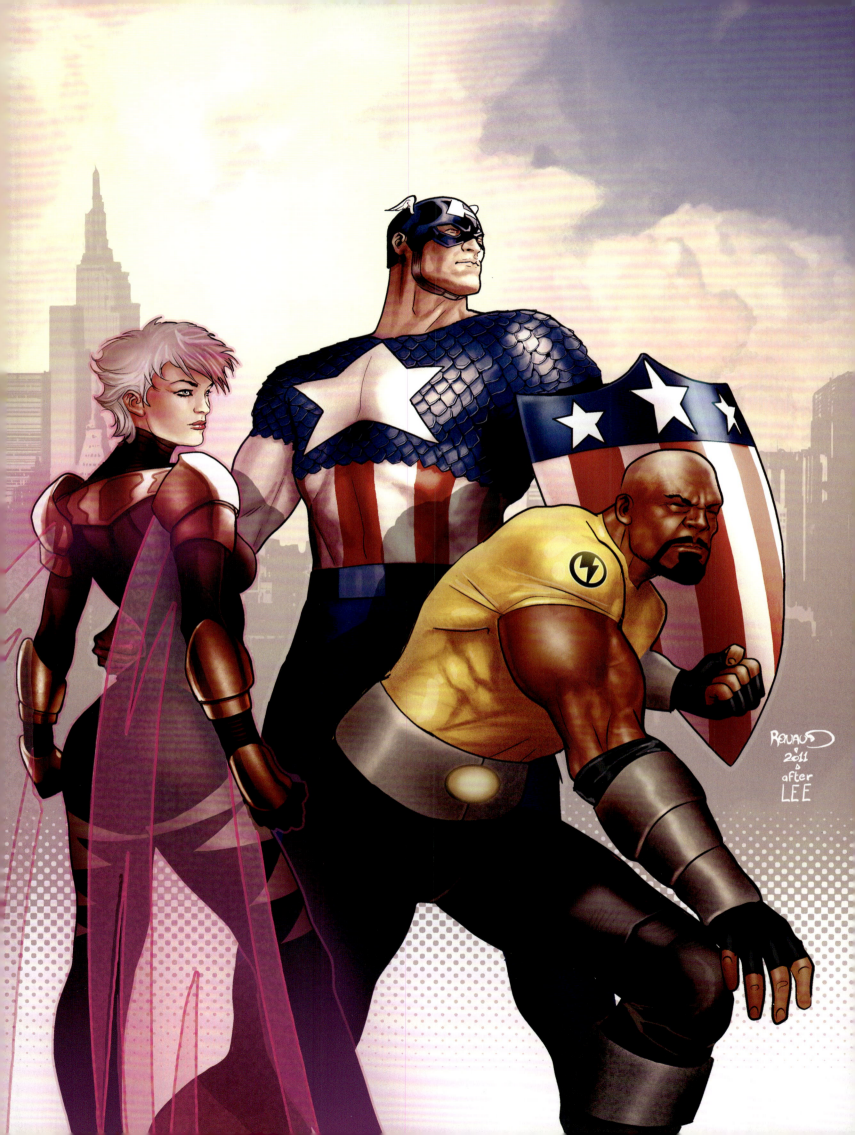

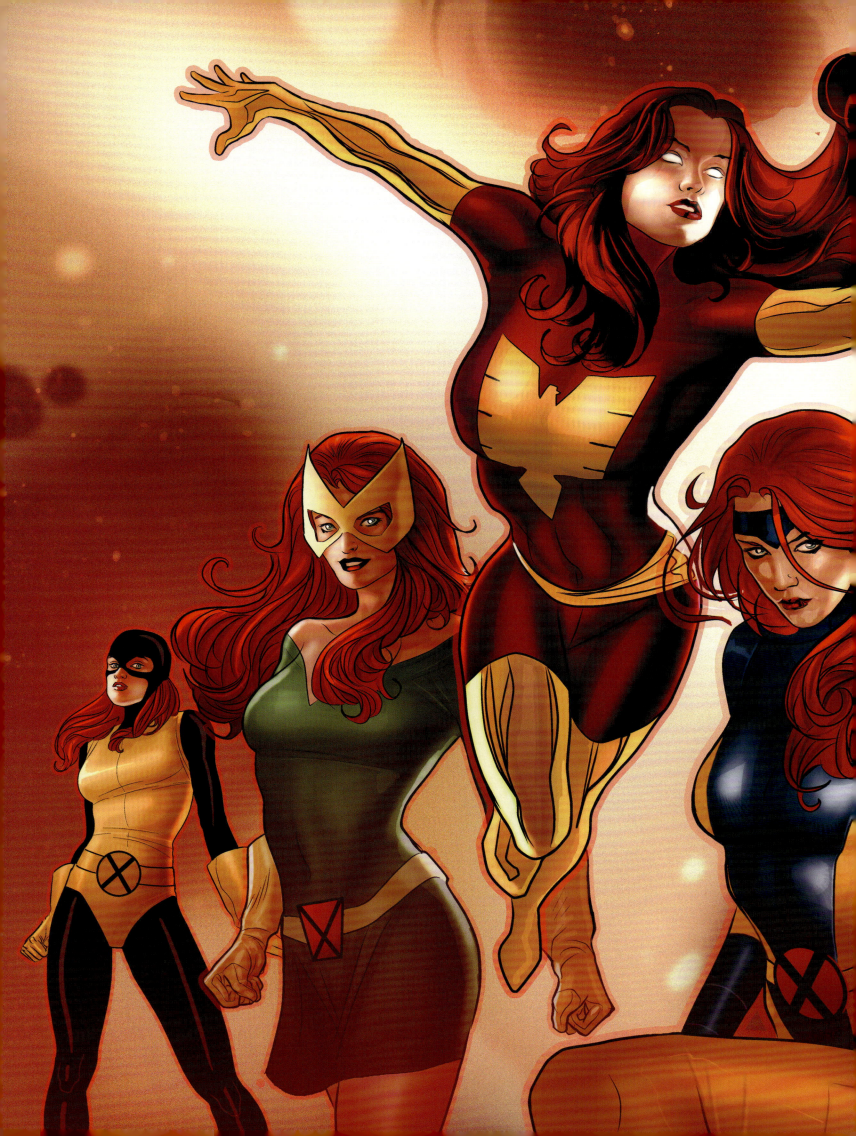

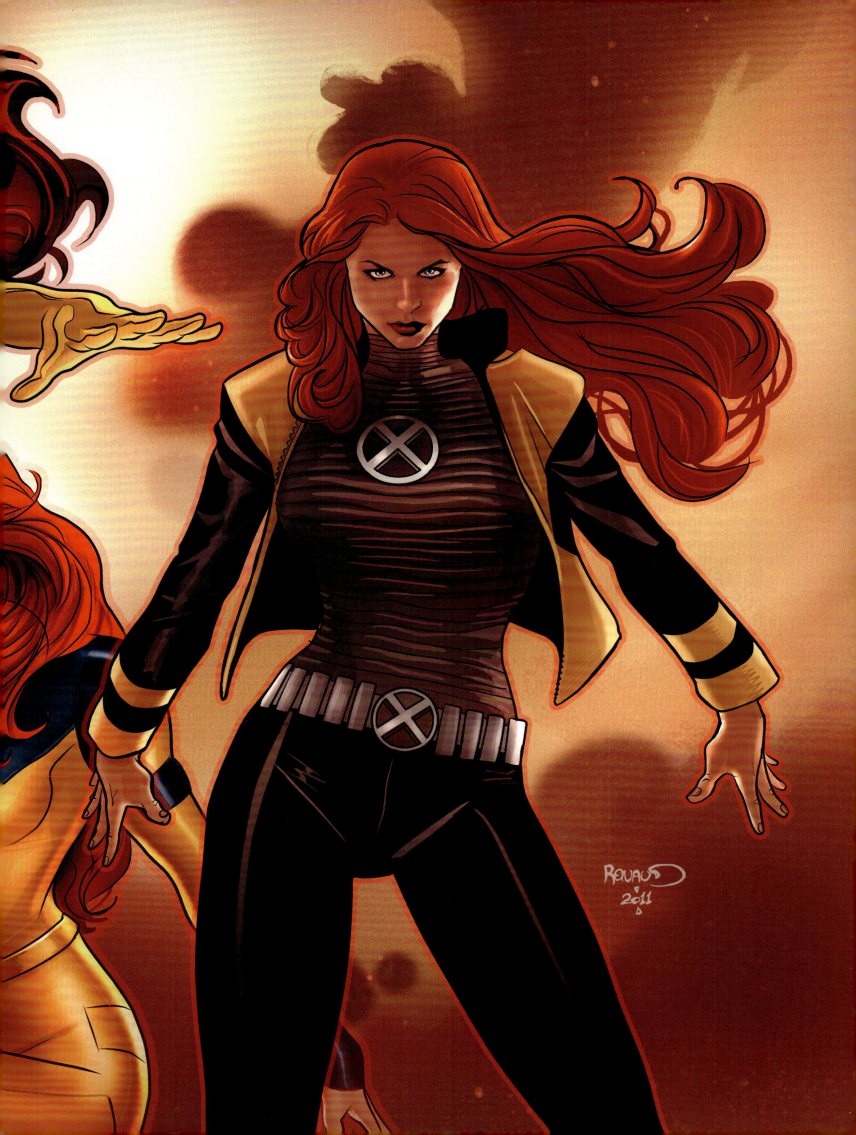

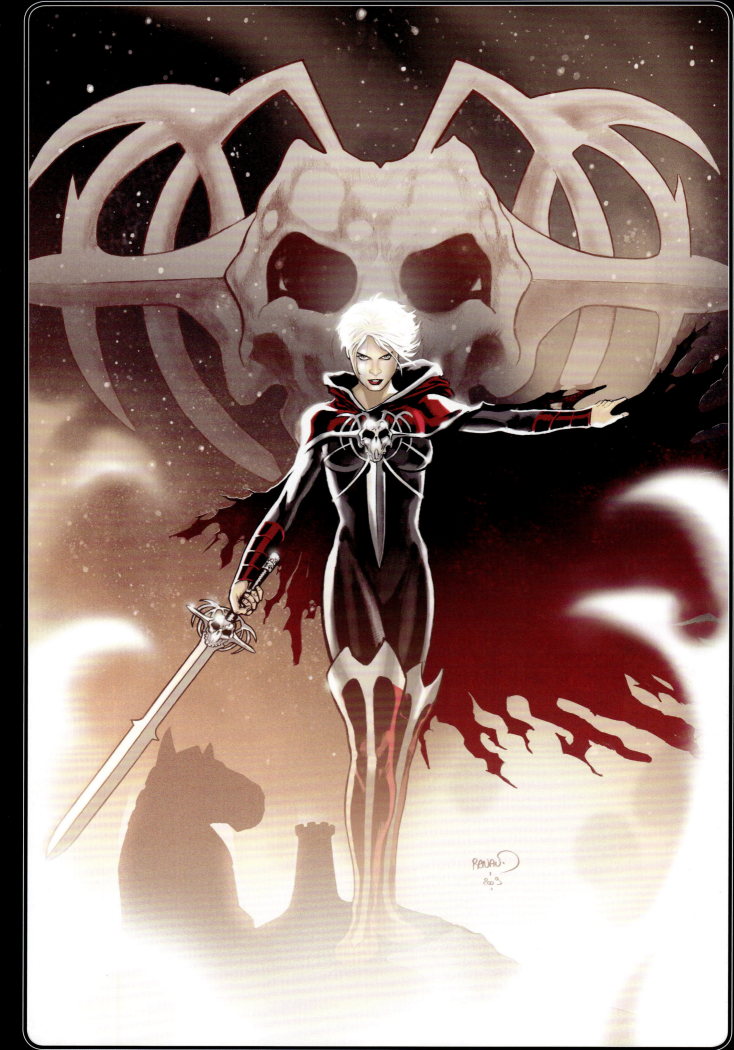
Guardians of the Galaxy

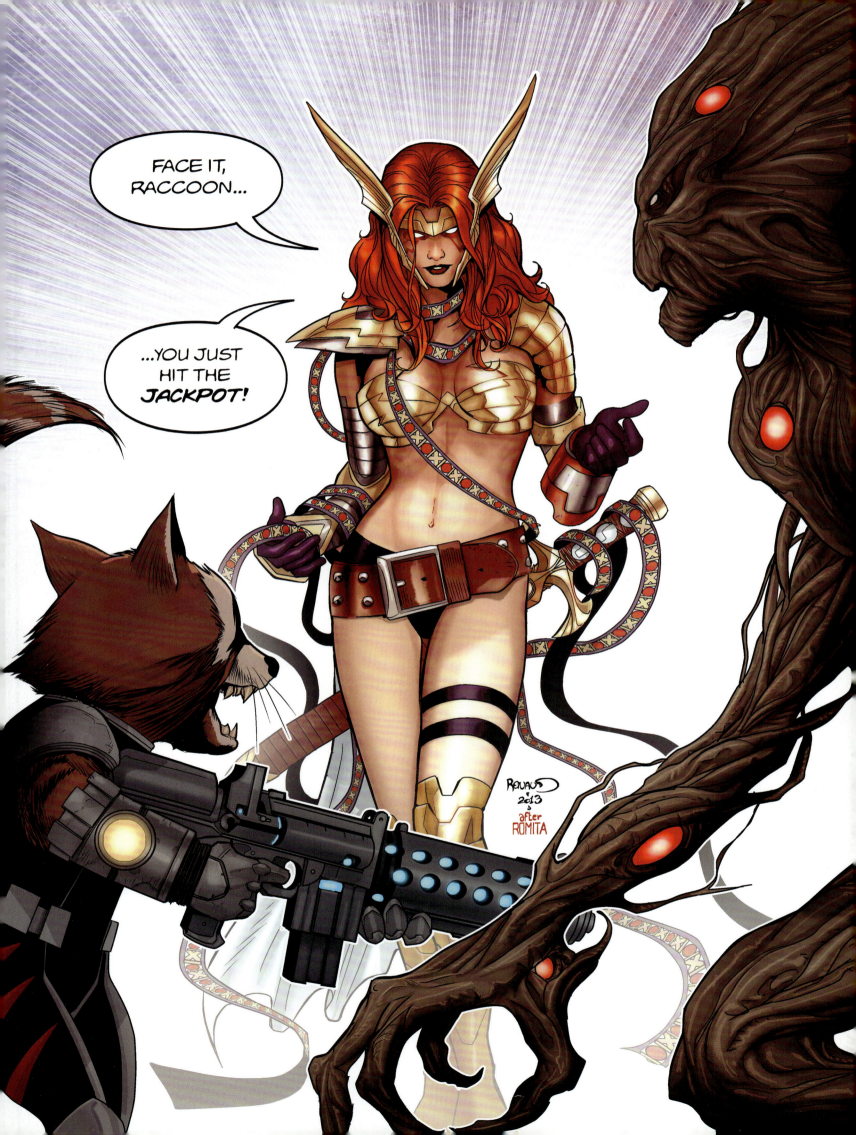

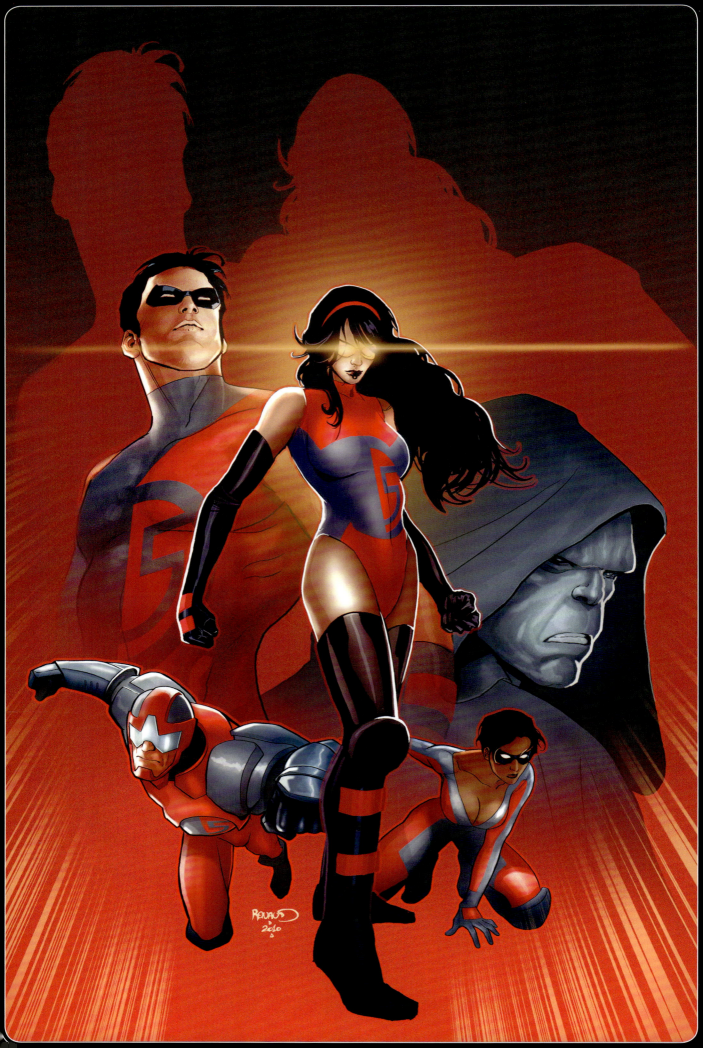

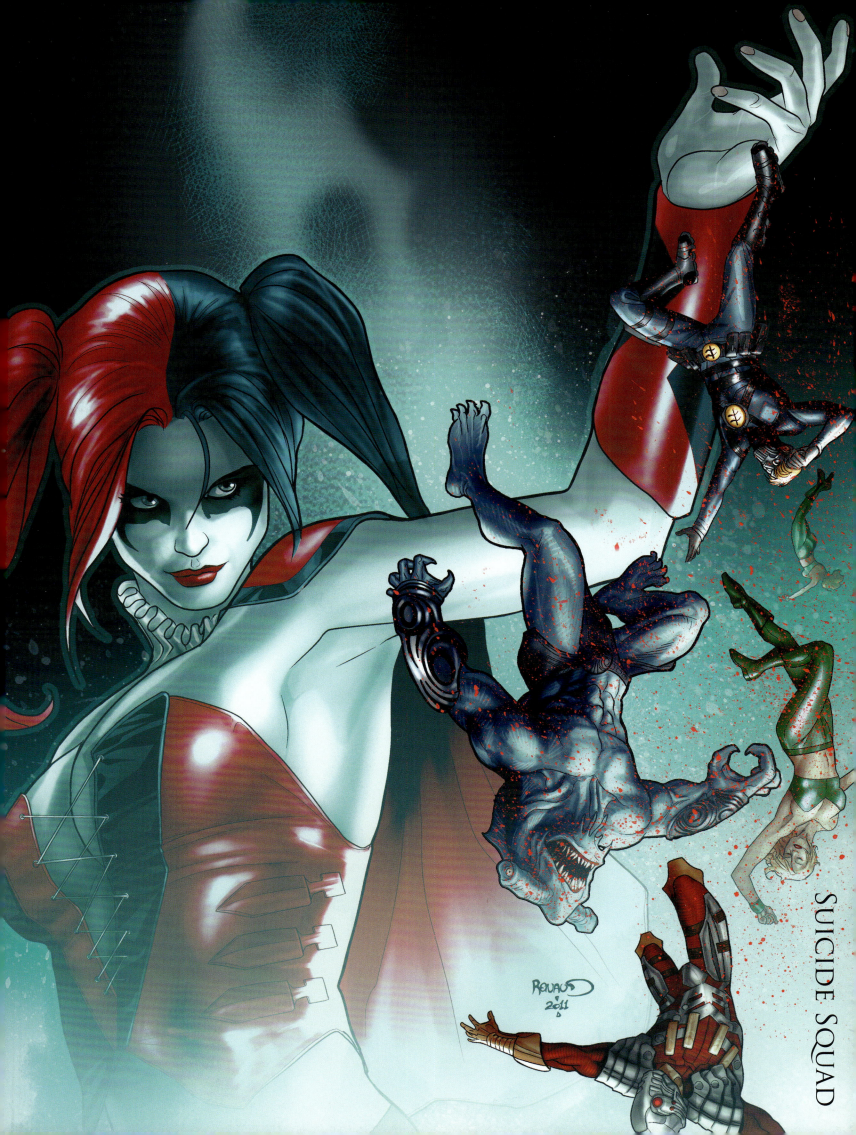

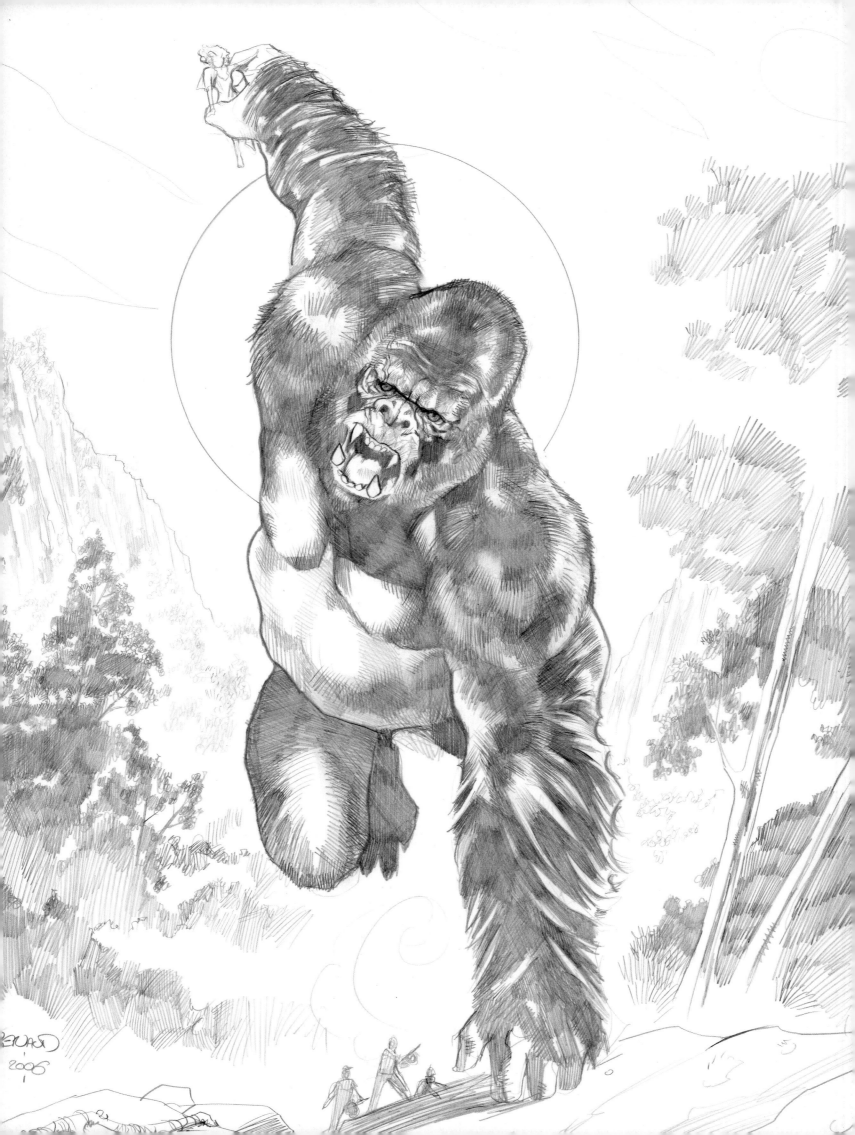

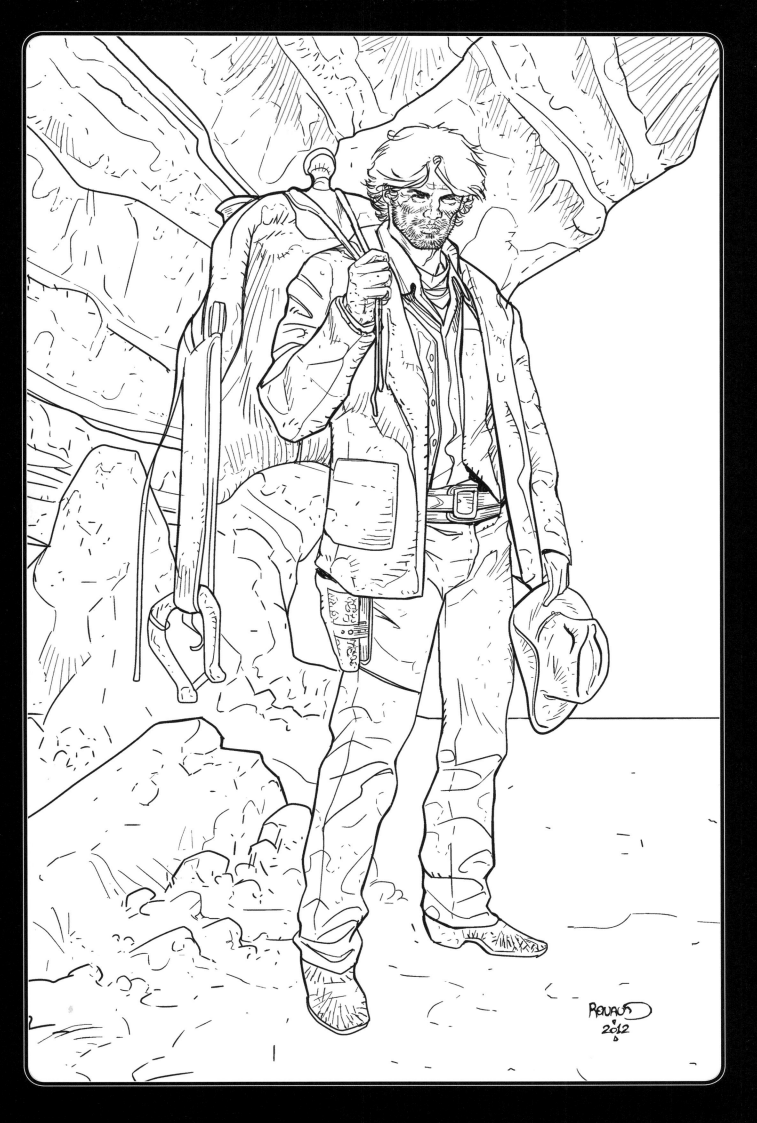

HOMAGE ART: MOEBIUS

Homage Art: Loisel

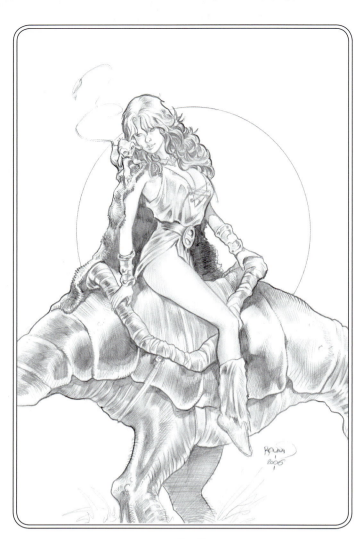
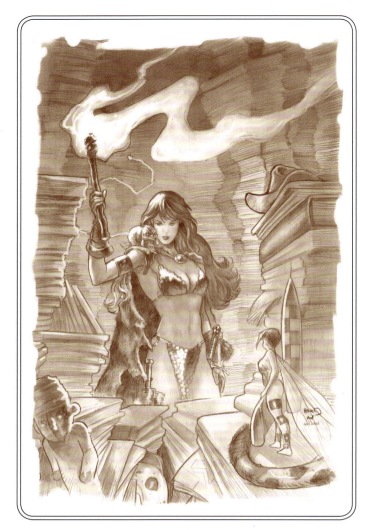

Who watches the watchmen...?

Homage Art: Alan Moore

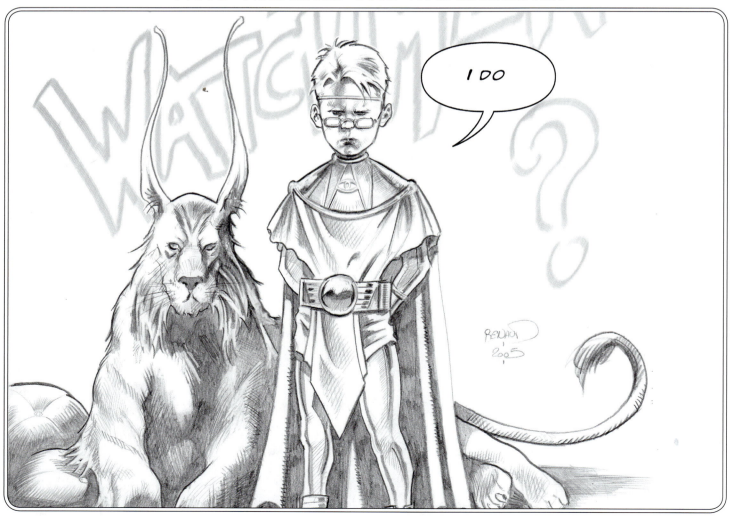

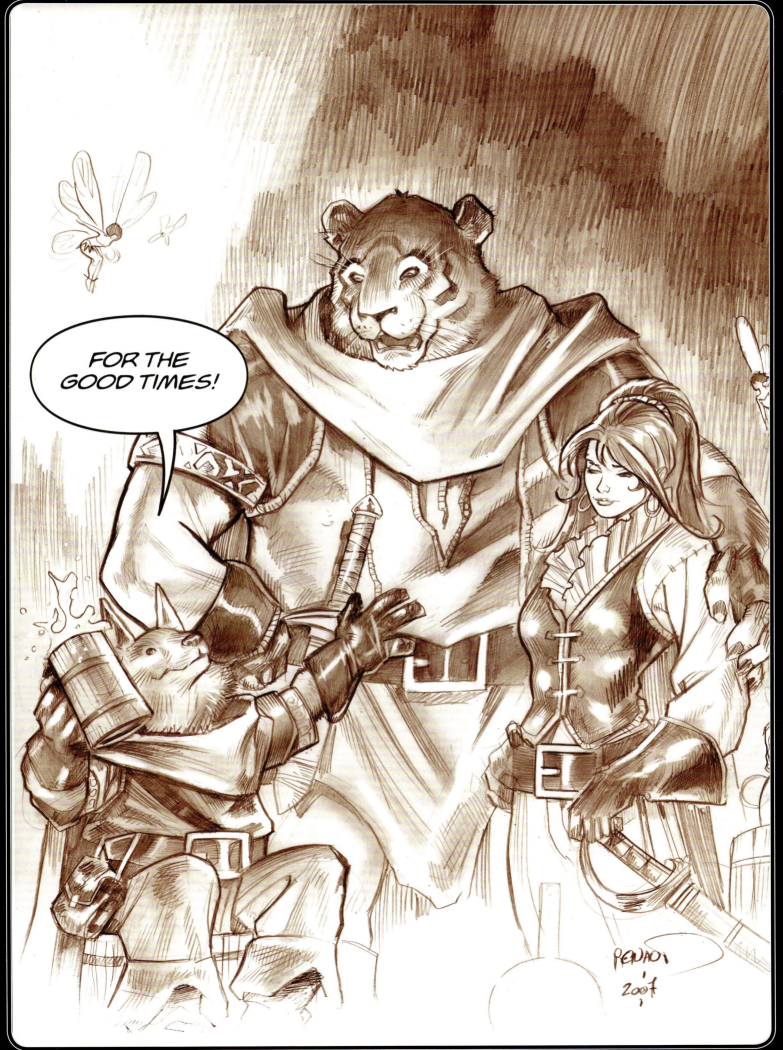

Homage Art: Usagi

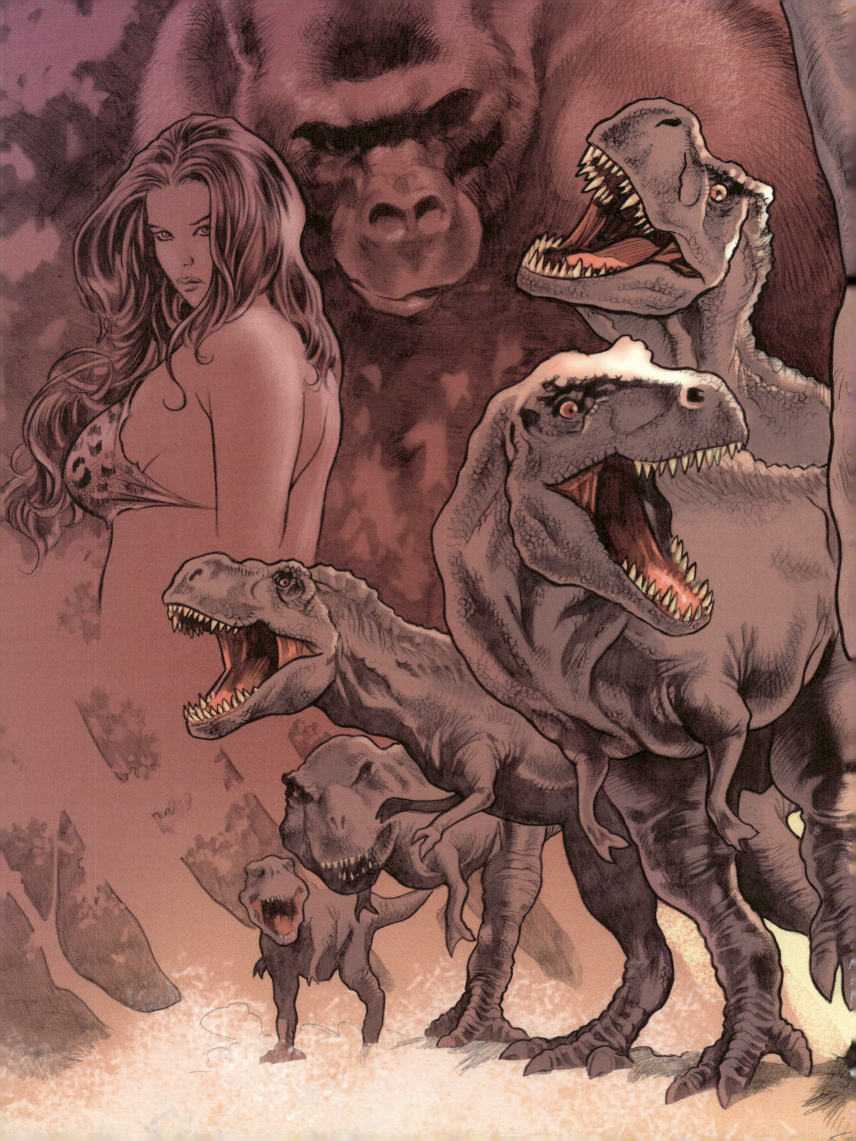